How to Draw Everything

How to Draw Everything
Copyright © 2015 by Gillian Johnson.
All rights reserved.
Printed in China.
For information, address St. Martin's Press, 175 Fifth Avenue, New York, N.Y. 10010.

www.stmartins.com

Library of Congress Cataloging-in-Publication Data is available upon request.

ISBN 978-1-250-07823-0

Originally published in the United Kingdom by Michael O'Mara Books.

St. Martin's Griffin books may be purchased for educational, business, or promotional
use. For information on bulk purchases, please contact the Macmillan Corporate
and Premium Sales Department at 1-800-221-7945, extension 5442, or write to
specialmarkets@macmillan.com.

First U.S. Edition: September 2015

10 9 8 7 6 5 4 3 2 1

How to Draw Everything

Gillian Johnson

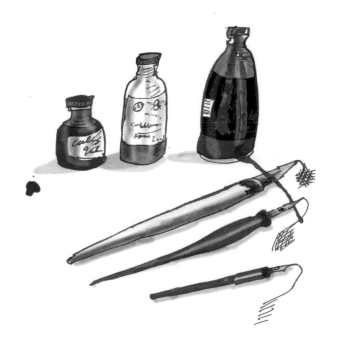

St. Martin's Griffin
New York

Contents

Introduction

Anyone can draw. The trick is not being scared to start.

I make my living as an illustrator and have published over 30 books. But a few years ago one of my projects went a little wrong. The text for the children's book was set, but my drawings seemed not to measure up. I was asked to draw and re-draw the preliminary sketches (the roughs): "make the boy a little taller," "we're after a looser line," "that street is all wrong," "it wouldn't look that way." I obliged, but it was soon apparent that there was a bigger problem. I just wasn't the right illustrator for the job.

"No!" they said. "We love your work!" So I finished the illustrations, posted them off and received a letter two months later, informing me that they had decided not to publish the book.

Okay, this happens sometimes. But what happened after this was disastrous for me. I developed **drawer's block**.

As a child, I drew anywhere and everywhere: on my freshly laundered sheets, on my bedroom mirror, in the margins of my school notebooks. As I got older, I took evening life-drawing classes. I especially liked drawing people. Unflattering portraits of members of my family were my specialty. I wanted to go to art school, but it never worked out. It didn't matter. I drew anyway. Evening classes, my spare time, weekends. Drawing was pure joy. It was where the illicit me found expression and pleasure.

So when I found myself unable to draw, I panicked.

Panic pushed me into full creative shutdown.

I began to itemize my failings as an artist. I decided that my washes were rubbish. I had no sense of perspective. I didn't know how to use a vanishing point properly. I couldn't draw buildings, bridges, cars, cats, sailboats or even my children. Yet there I was, identifying myself on my LinkedIn profile as "illustrator and writer." Maybe I was a fraud . . .

So how did I get over "drawer's block"?

To start with, I thought a lot about how I learned to love drawing in the first place.

I needed to return to that place where there

were no censorious voices. Just the pleasure of the line on the paper.

I worked out a series of exercises to free up my mind and loosen my imagination. And that led to this book – which is about how to turn off the voices saying "no" and draw, without being scared that the results "won't be good enough." And how to keep going until you start to be happy with the results.

Given its ability both to focus and release the mind, it is no surprise that drawing is often used as a form of therapy. But many people look at a blank piece of paper and find the idea of drawing something from scratch intimidating. They think that they will have to learn a lot of rules about perspective and how to draw faces and so on.

The exercises in this book are all designed to help you to forget that fear and allow yourself the freedom to be creative.

People talk about how drawing makes you observe more accurately – how it helps you to remove the scales from your eyes and appreciate an object with new clarity. "Ah, the arm doesn't actually grow out of the neck" sort of thing. But as an illustrator, you can find yourself embracing your bad habits. Many of my characters, for example, don't even have necks. And they look pretty good.

So it's not just about seeing the world afresh, but also yourself.

As a child, I had a dog called Lucy. She was one of those inbred Springer Spaniels, adorable but neurotic. When we went out, we had to lock her in a cage or she would shred the house. When I draw, I feel like Lucy must have felt when we let her out of the basement cage – a sense of boundless possibility as she raced up the stairs and headed outside for a breath of fresh air and a toss of the ball. I draw because it connects me to something deep down that needs to be aired.

I have tried marathon running, yoga, smoking, boot camp, travel, alcohol, meditation, walking, but it is only drawing that allows me simultaneously to escape and engage. When I draw, I feel completely absorbed and connected. When I am finished drawing, I feel refreshed and happy.

Drawing is the way I stay sane.

This book is not about drawing super-realistically, but about taking your line for a walk and seeing where you end up.

Have fun.

Art Materials

You could do most of the exercises in this book using whatever drawing materials you already have to hand. However, if you do decide to buy some new supplies . . . BEWARE! Art stores are seductive as well as expensive places to hang out.

Here is a list of basics that will see you through this book if you want a few more options.

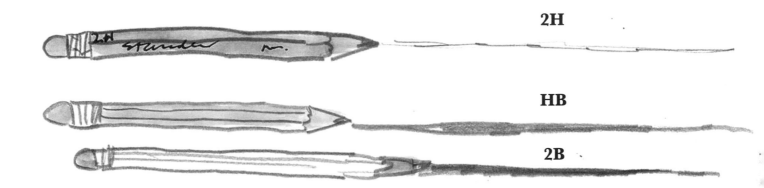

2H

HB

2B

Pencils – use a range of hard to soft.

A pencil is an excellent drawing tool. Pencils use a system of categorization that measures the hardness of the lead. (That's what the "H" stands for.) Many of us used HB at school: a middle-of-the-road kind of pencil, not too hard and not too soft.

Personally, I find the HB lacking in oomph. I prefer the 4B which makes a dark but not too smudgy line. The 9B, on the other hand, is very black and a bit messy to work with. And then you have the 9H, where the hard lead produces a light line suitable for very fine detail work.

Pencils have been around for a long time. In the sixteenth century a massive deposit of graphite was discovered in Cumbria, UK, but it took two Italians to encase the graphite in what we properly call a pencil now.

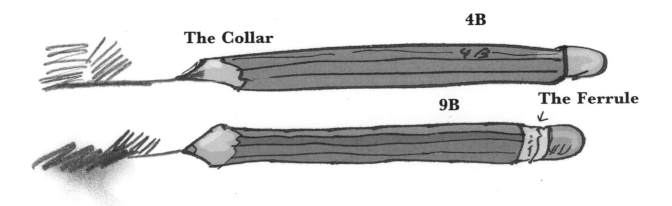

4B

The Collar

9B

The Ferrule

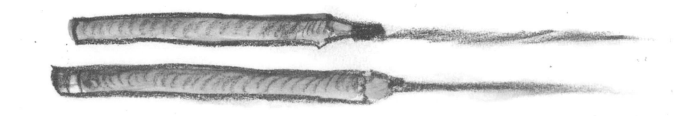

Charcoal pencils can be used for a soft smudgy effect.

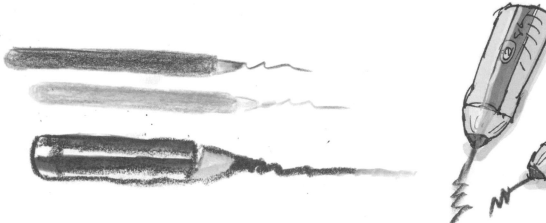

A range of colored pencils.

In many art stores you can find a range of "multi-talented pencils" (above right) that are extremely versatile: part wax crayon, part regular pencil.

I love the versatility of Conté crayons.

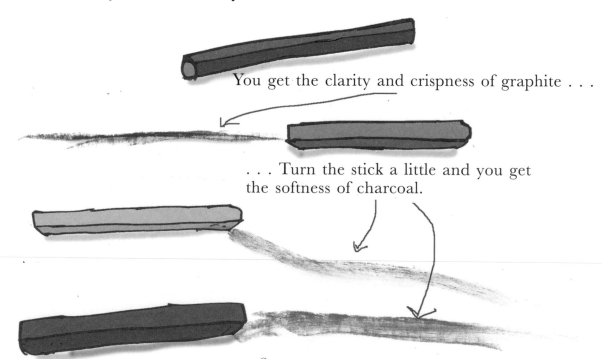

You get the clarity and crispness of graphite . . .

. . . Turn the stick a little and you get the softness of charcoal.

India Ink. I use a permanent fast-drying brand that allows me to apply washes once dried.

Dip pen with steel nib.

Pastels – good for layering and blending.

Felt-tip markers – try a variety of nib sizes.

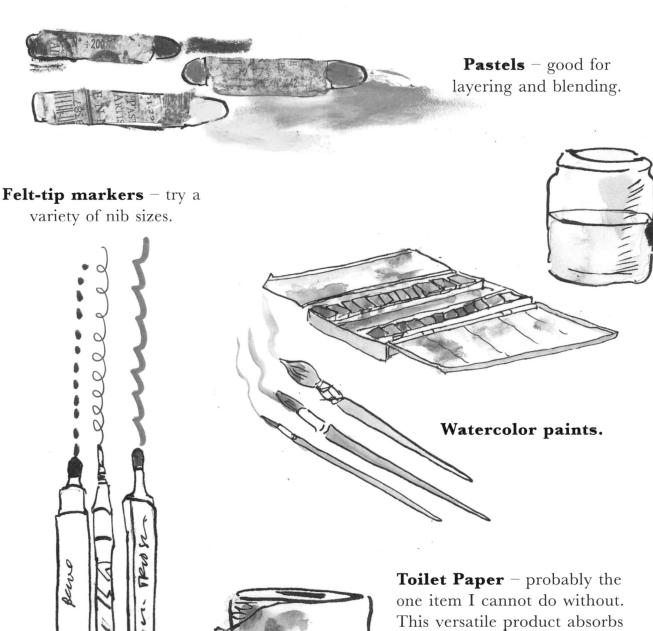

Watercolor paints.

Toilet Paper – probably the one item I cannot do without. This versatile product absorbs errant paint, blots brushes and excess ink, and drinks up splats from temperamental markers and dip pens. A must-have in all art studios.

Getting Started

This book has been made to help you overcome . . .

. . . your fear of the blank page.

Getting started is always hard. Think about how you feel when you head out for a walk or run. You might feel creaky for the first few steps, but once the blood is moving, you begin to loosen up, to shake out the cobwebs. So instead of a bunch of static drawing exercises, let's hit the tarmac running.

Don't worry about realism. We are looking for movement. A dynamic warm-up will focus your mind and get your blood flowing. Increased blood flow equals greater mobility – which in drawing terms, releases you, the artist, more fully into the drawing experience!

I promise you, this is NOT a book about exercise. However, I do encourage you to give your body a bit of a twirl before you sit down to draw. Arm circles loosen up your shoulders and upper back, and increase blood flow. A quick walk or jog can help you get into the zone by calming down your mind. I don't want your brain criticizing and sabotaging you – I want it flowing down, through your body into your pencil or pen. In other words, we're after the kind of reality that a camera can't get. Good drawing is not copying the surface: *it's rendering the essence.*

But before you draw anything, let's get those hands moving across the page . . .

Let's Get Scribbling!

Choose a fine black pen or pencil and make a scribble in the spirit of this.

I can't think of a better way to get to know your black pen. Scribbles fascinate me. Continuous circles of scribbly lines evoke such a wide range of emotions. Perhaps this explains why so many psychologists and art therapists use scribbling in their work. But the idea that anybody "invented" scribbling as an art form is as silly as a scribble. Just look at the way small children use their fingers to make marks on a steamed-up window, or on a wall or cardboard box with a crayon. It's an innately pleasing activity.

Musical Scribbling

You can use rhythm to develop your scribbling into more complex patterns. I started listening to Beethoven's *Moonlight Sonata* and made the scribble below. The stronger music resulted in more emphatic lines. Try playing some music using your pen as the conductor's wand.

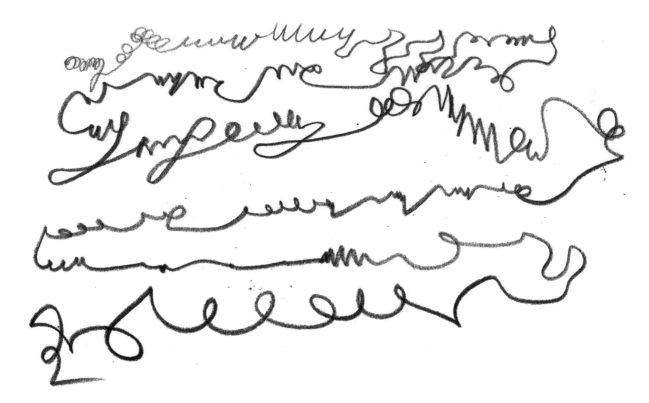

Make some scribbly flowers!

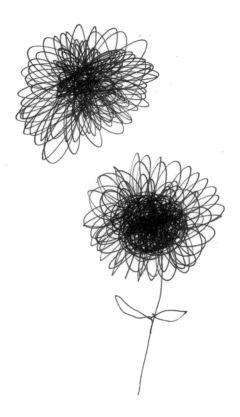

Try scribbling with the hand you don't usually draw with.

You can use scribbly techniques with other art materials too.

Draw a box and use crayons or thick pencils to fill the space.

Black crayon

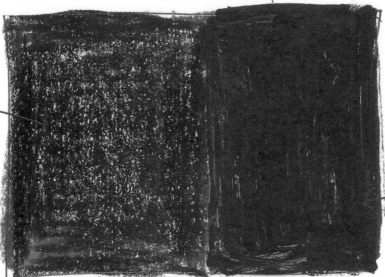

Cover with black crayon or India ink.

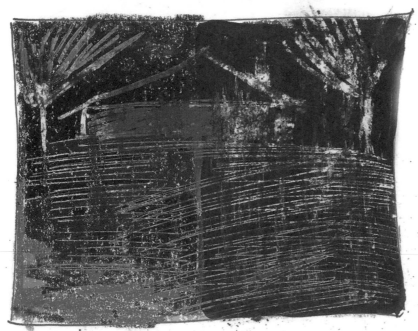

Scratch patterns using the tip of a knife or anything sharp.

Use some pencils, crayons or India ink to scratch out an image below.

. . . doodling . . . doodling . . . doodling . . . doodling.

The best time to draw is any time. Like now . . .
Even if it is just letting your pen start moving
around on this page and seeing where it takes you.

. . . doodling . . . doodling . . . doodling . . . doodling.

Doodle Boxes

As with exercise, the flow often kicks in after you start. So if you're not sure where to start looking for that inspiration, try beginning with simple shapes.

Fill this box with circles. Add eyes, noses and mouths.

Fill this box with squares. Turn them into presents . . . or cars!

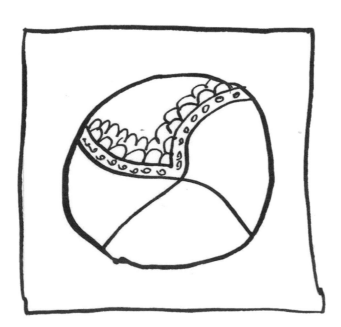

Finish decorating this circle, then keep doodling and fill in the background.

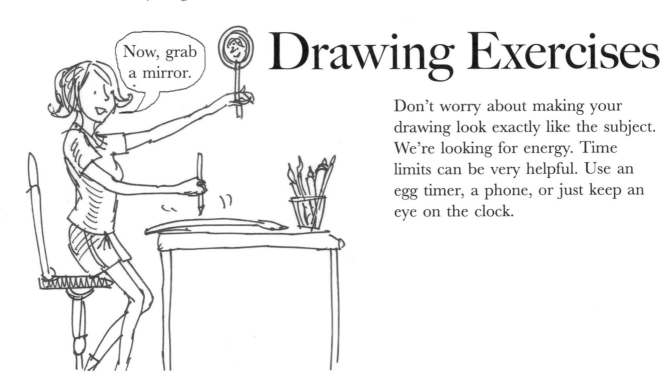

Drawing Exercises

Don't worry about making your drawing look exactly like the subject. We're looking for energy. Time limits can be very helpful. Use an egg timer, a phone, or just keep an eye on the clock.

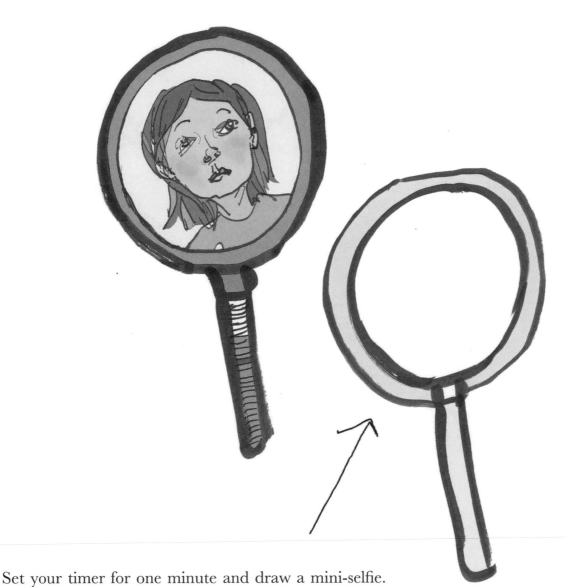

Set your timer for one minute and draw a mini-selfie.

Now try one that takes five minutes.

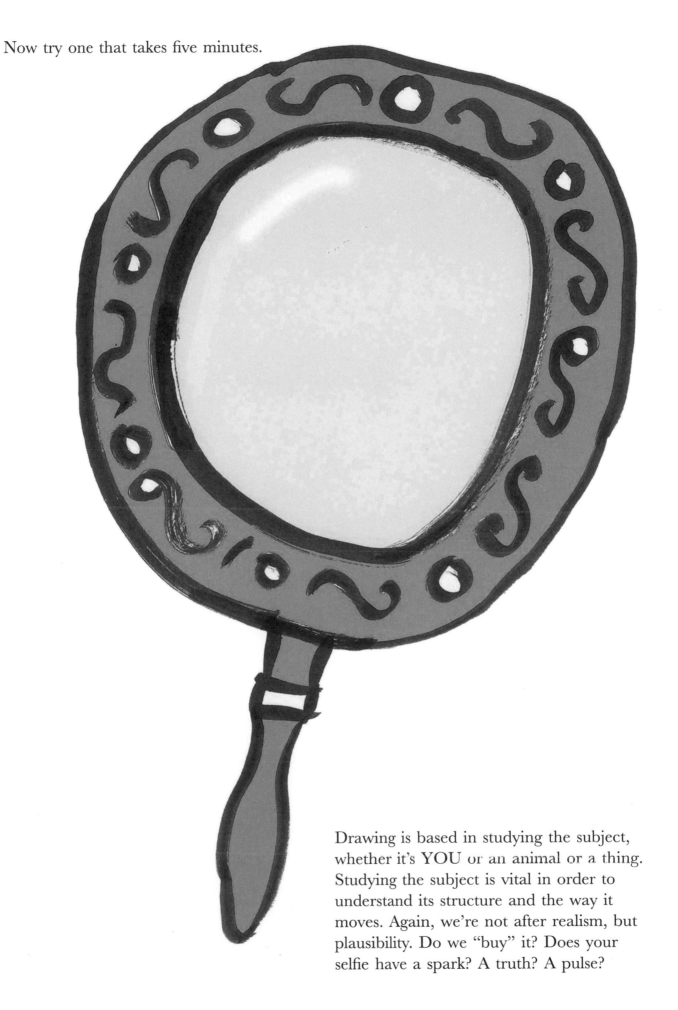

Drawing is based in studying the subject, whether it's YOU or an animal or a thing. Studying the subject is vital in order to understand its structure and the way it moves. Again, we're not after realism, but plausibility. Do we "buy" it? Does your selfie have a spark? A truth? A pulse?

When your mind goes blank, you need to have a plan.

Now, it's time to change focus from yourself to the world around you. But where do you start? The world around you is a big place and this immensity can overwhelm even the most motivated artist. When your mind goes blank, you need to bring it back to the basics.

Plan 1. Draw whatever you can see from wherever you are sitting. Focus on the smaller, more manageable items. Here are a few things in the room around me:

Now you try.

Plan 2. Go into your kitchen and open the refrigerator door.
You should find a lovely collection of boxes, cylinders and other shapes to draw.
Choose four items and sketch them. Take them out of the refrigerator if it's easier.

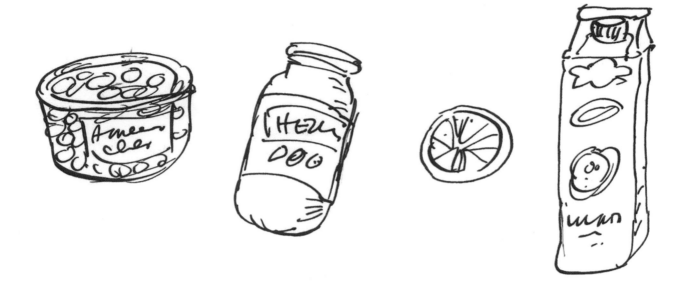

Sometimes when we use a dip pen, things don't go according to
plan. Blots, splodges, drips are all common. So are scratchy nibs.
Go with it. The accidents + scratches can add LIFE.

23

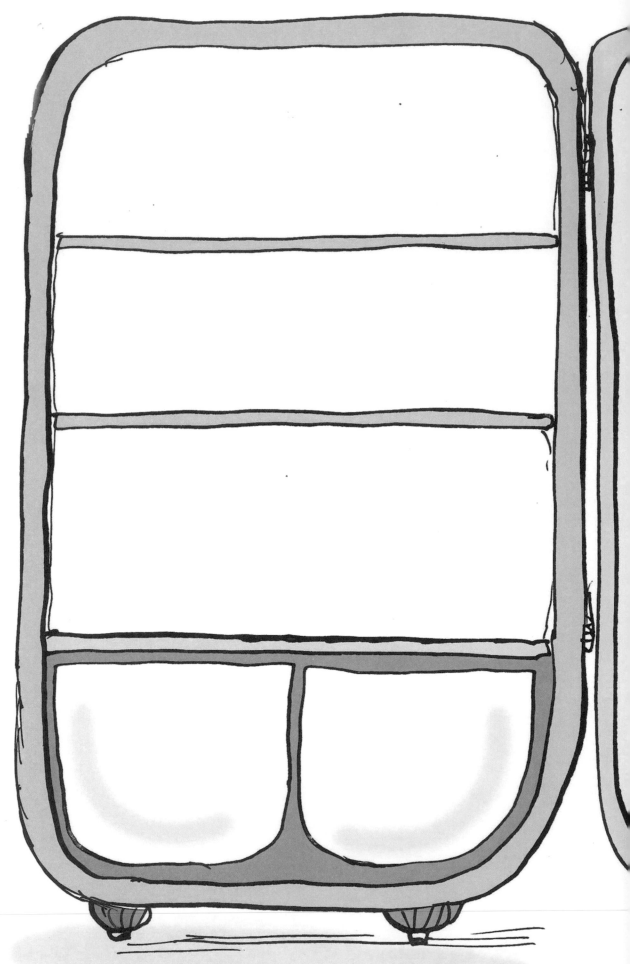

Now, stock this refrigerator with food and drink.

Plan 3. Look around your house at your windowsills – are they cluttered?
Random? Zen?
**Add some of the objects from your own house to this
windowsill and cabinet.**

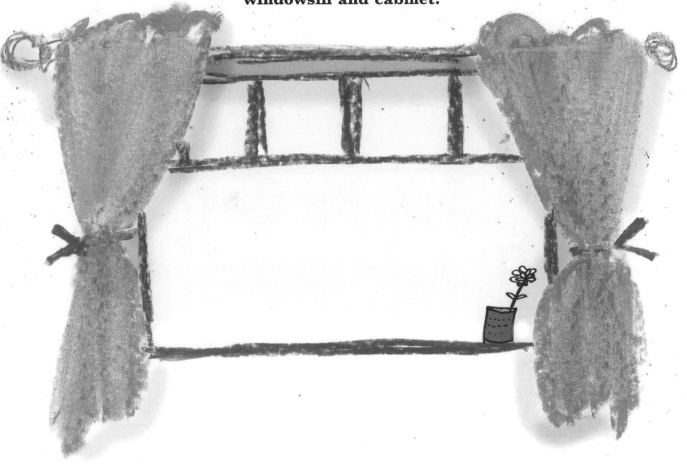

Drawing With Your Non-Dominant Hand

Try drawing something with the hand you don't usually draw with. Here's a guitar I drew with my "wrong" hand.

Drawing the Spaces

This is an exercise that helps you to see objects more clearly without overthinking them. Take something with an interesting outline, like a house plant, or a chair and table. Don't draw the object! Instead of drawing the chair, draw the shape of the spaces between its legs and the space around the back of the chair. Then shade in the spaces, so that you leave white space where the object is.

Continuous Drawing

This is an exercise in taking your line for a walk. Here we are going to get you to draw your subject in one, unbroken, continuous line. Don't worry about retracing your steps and doubling back over the same lines. This is a terrific exercise for encouraging your hand and brain to work together. It doesn't have to be perfect. Here's one I did in a coffee shop.

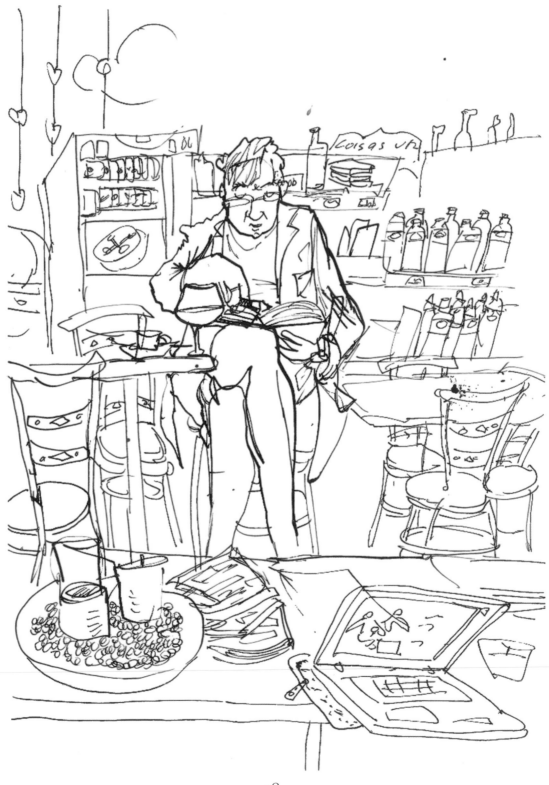

**Draw part of the room you are in using a continuous line.
Give yourself five minutes.**

The Joy of Repetition

I love the freedom that comes with cheap photocopier paper. Sometimes I live it up and buy the heavier paper that is used in higher quality printers. This also comes with an extra smooth surface that responds brilliantly to most drawing media, especially pen and ink. It will even hold light washes without wrinkling too much. I do huge numbers of drawings that I never show anyone. And I don't feel bad about throwing them away. Many of the drawings that end up in the recycling bin are rough drafts. I like to see them as my warming-up exercises. They are not mistakes or disasters, but stepping stones. Drawing the same thing over and over is a way of learning how to draw it.

On these two pages, draw the same object 15-20 times in quick succession.

Random Drawing

Open a book or magazine (one with pictures in it), and put your finger on the page until you find an image. Or open an internet browser on your computer, search images and press random buttons on your computer. Then draw whatever you find on this page.

The Visual Workout

Another way to get going is with a workout regime. Swedish people use a training method called a "fartlek", which means "speedplay." This relies on a physical blend of different kinds of exercise in short bursts.

In the same spirit, the workout on the next two pages combines different drawing activities, varied art utensils and alternating speeds into a continuous drawing flow that will hone your seeing as it loosens your lines.

The exciting feature of this workout is that it is a relaxed way to be structured. This ties in nicely with the ethos of this book. Don't worry about making your drawing look like a photo. Save that for photos. We are after your LIFE FORCE, no less. We want you to connect with something joyful and release it into the lines on the paper in front of you.

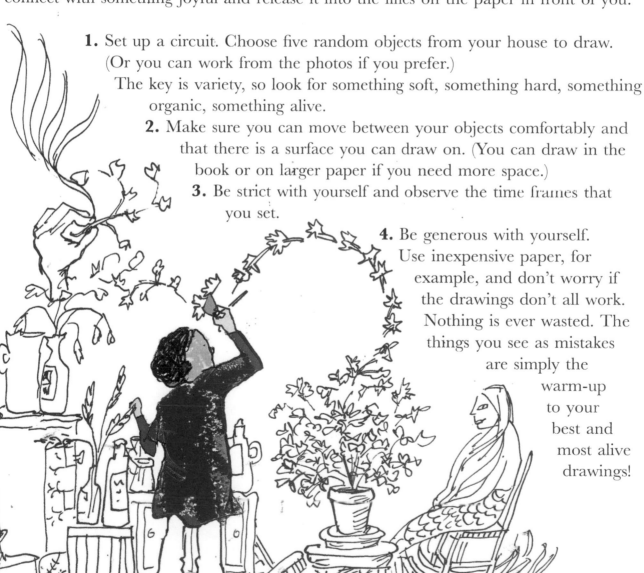

1. Set up a circuit. Choose five random objects from your house to draw. (Or you can work from the photos if you prefer.) The key is variety, so look for something soft, something hard, something organic, something alive.

2. Make sure you can move between your objects comfortably and that there is a surface you can draw on. (You can draw in the book or on larger paper if you need more space.)

3. Be strict with yourself and observe the time frames that you set.

4. Be generous with yourself. Use inexpensive paper, for example, and don't worry if the drawings don't all work. Nothing is ever wasted. The things you see as mistakes are simply the warm-up to your best and most alive drawings!

33

Your task: Draw each of the objects using the following strategies:

1. *With a fat pencil or crayon, in one minute.*
2. *With the hand you don't usually draw with, in five minutes.*
3. *Without looking at the paper, in two minutes.*
4. *Upside-down, in three minutes.*
5. *With a black marker pen, in two minutes.*

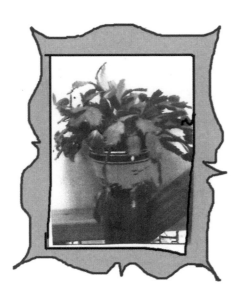

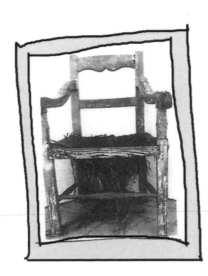

Draw a House

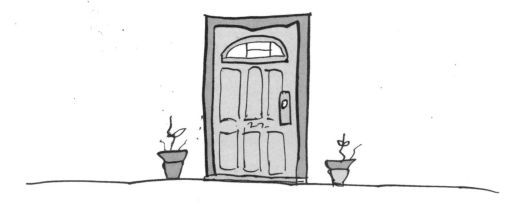

Use this door.

You have many more images than you imagine stored in your personal visual archive. However, when you go outside and draw an actual house, you'll find that you notice all kinds of details you wouldn't come up with for an imaginary house: external wiring, broken tiles, locked-up bicycles, and furniture seen through the window. By doing this, you can discover just how much your memory compresses and abbreviates objects in the real world.

Here are a couple of sketches of houses near to my home.

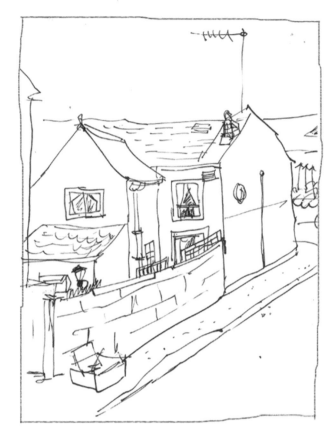 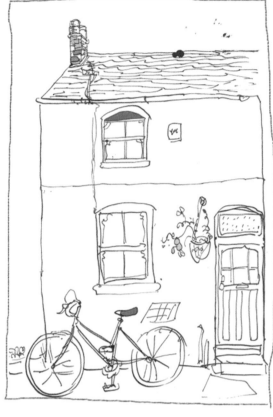

Now go outside and draw a house in your local area
and see how different it is.

Finger Painting

The only requirements for finger painting are at least one finger, some non-toxic paint (or ink) and an ability to make a small mess. Finger painting is fun and therapeutic, as the educator Ruth Shaw understood when she introduced it to her progressive school in the 1930s. It seems that people have always liked to smear materials on white paper (or white walls, as children learn early). Thumb and fingerprints are a variation on finger painting.

1. Fill a cap or small bowl with diluted India ink.

2. Dip your finger in.

More blots to get down and dirty with . . .

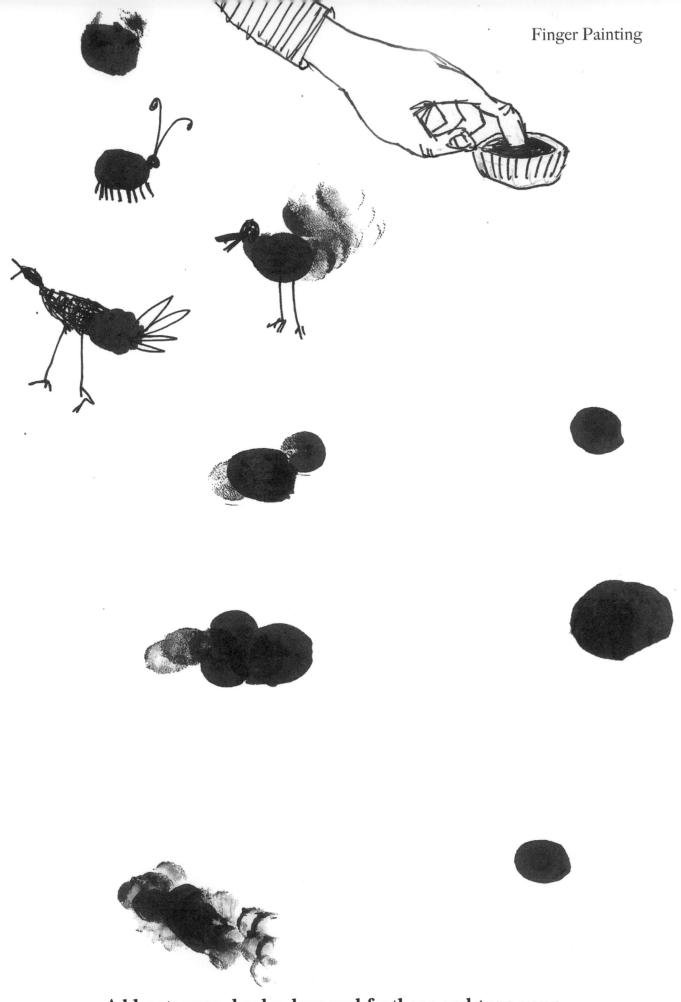

Add antennae, beaks, legs and feathers and turn your blobs into bugs, animals, monsters and aliens . . .

Splodges and Smudges

Expand your splodge repertoire to include oil pastels, which have excellent smudge value. Apply a heavy blob and watch it grow into something unexpected.

Lay down a few strokes in pastel.

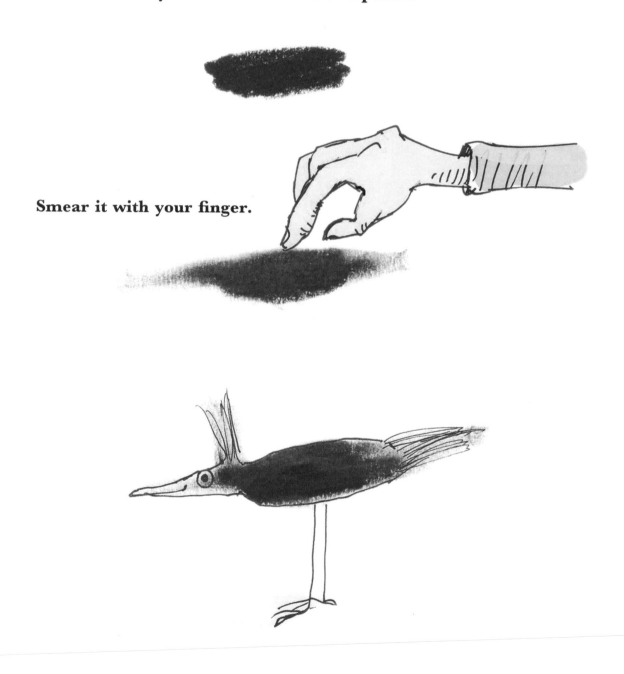

Smear it with your finger.

Now add some detail with a fine black pen.

Here are a couple of ready-made splodges (and space for you to try a few more yourself).

Mixed Blurs

Try mixing different media. This is blue chalky pastel combined with flesh-toned oil pastel. It's a fun way to create odd but simple people.

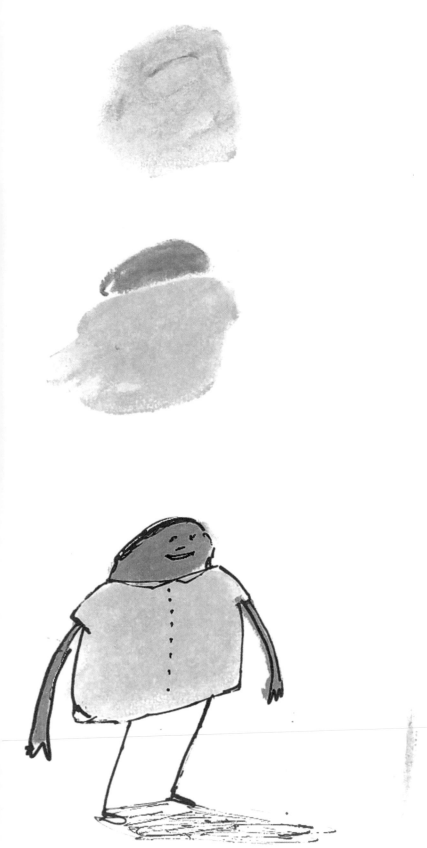

The Easy Way to Understand Perspective

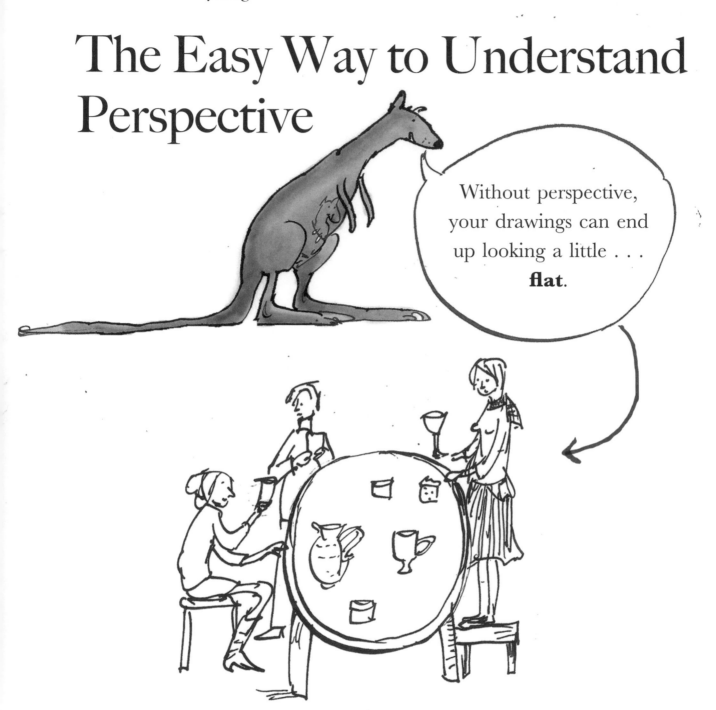

Without perspective, your drawings can end up looking a little . . . **flat**.

The basic idea of perspective is simple.
The closer you are to your subject the bigger they seem.

This baby looks like a giant baby . . . But it gets smaller . . . as you step back.

The Vanishing Point

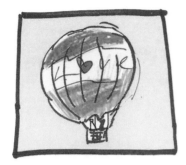

As a hot air balloon . . .

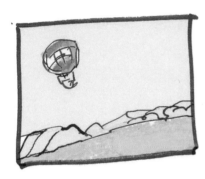 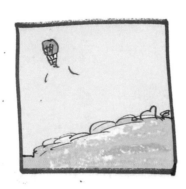

rises higher and
higher . . .

it gets smaller and
smaller.

The point where it disappears is called the vanishing point.

Avenue of Trees and Buildings

1. Draw a line across the middle of the box. This is the horizon line.
2. Draw a dot in the middle. This is the vanishing point.
3. Draw diagonal lines from the dot to corners A, B, C, and D.

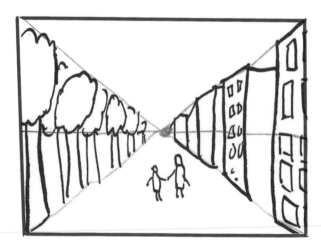

4. Draw trees on one side and buildings on the other, using the lines to find the correct proportions.

What is a Horizon Line Anyway?

Look out of the window.

The horizon line is where the earth meets the sky. It is also called eye level.

Things below the horizon line are below eye level. It appears that you are looking down.

Things above the horizon line are above eye level. It appears that you are looking up.

This horizon line and vanishing point are very bare.
Could you add some interesting details to liven things
up? Consider the merits of trees, hills, mountains, distant
buildings, a fence . . . Perhaps some wildlife?
A kangaroo? A mouse?
You can finish decorating the frame too if you want.

Drawing a Room Using a Vanishing Point

Here is a quick sketch of a room, using a vanishing point to create perspective.

And here is an empty room with a vanishing point. Try filling it up with some furniture and other objects.

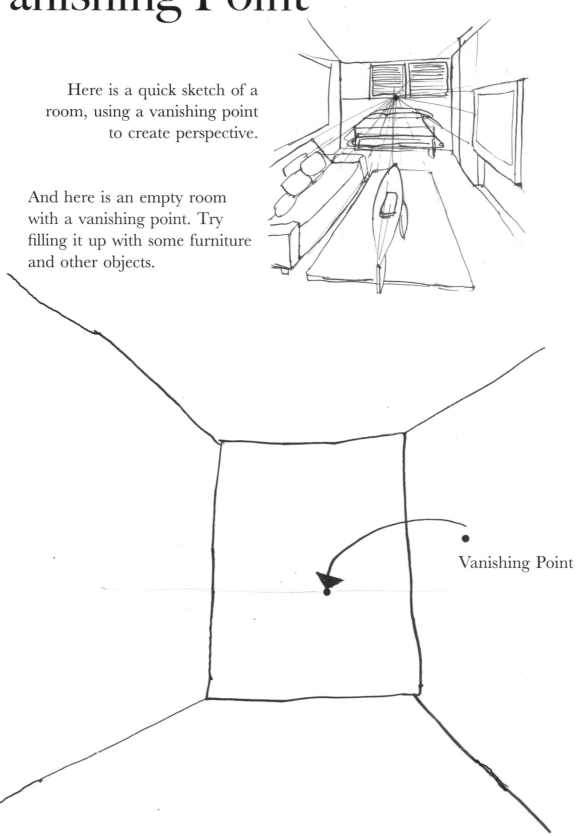

Vanishing Point

Light and Dark, Form and Shadow

Light and shadow define an object. The many different shades between black and white are called "values." When you draw, you need to interpret the light and shadow and turn it into shading. Shading gives objects a third dimension.

Here are some quick drawings with shading added:

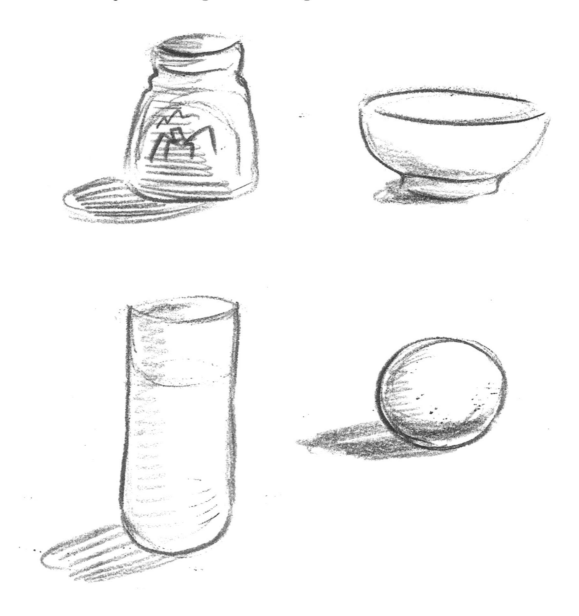

Try drawing some simple objects then adding shading.

51

Try drawing some simple objects then adding shading.

Hatching

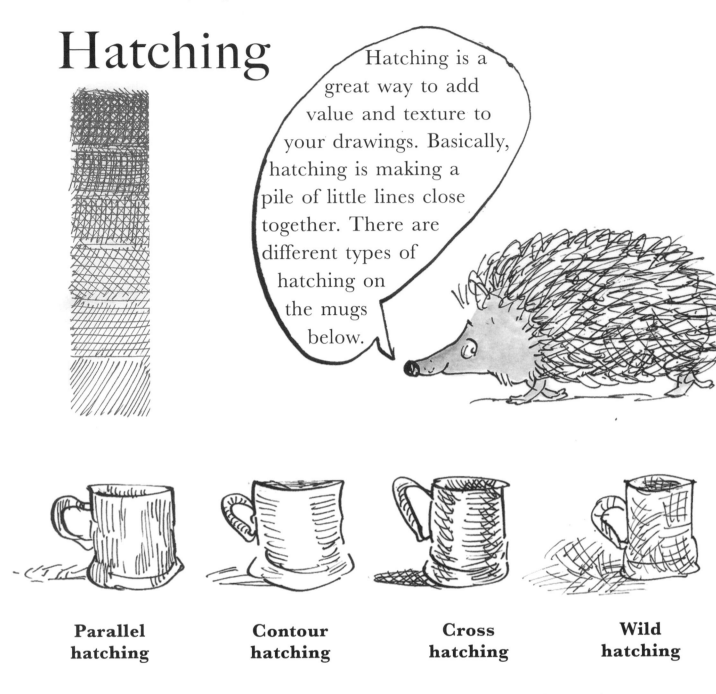

Hatching is a great way to add value and texture to your drawings. Basically, hatching is making a pile of little lines close together. There are different types of hatching on the mugs below.

Parallel hatching

Contour hatching

Cross hatching

Wild hatching

Too much hatching can deaden a drawing and it's important to know when to stop yourself. I love cross hatching. It calms me down. (A friend calls me "Scritch" because of the sound my pen makes as I cross hatch my way through our telephone conversations.)

Try cross hatching to add shadow and value to these mugs.

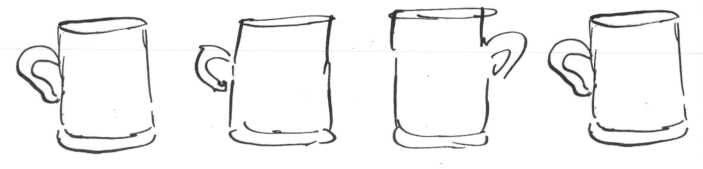

53

More Hatching

As you gain confidence in hatching you will find that even a simple drawing can be given depth and structure. My first drawing on the left is really basic, but I've used hatching to build it up.

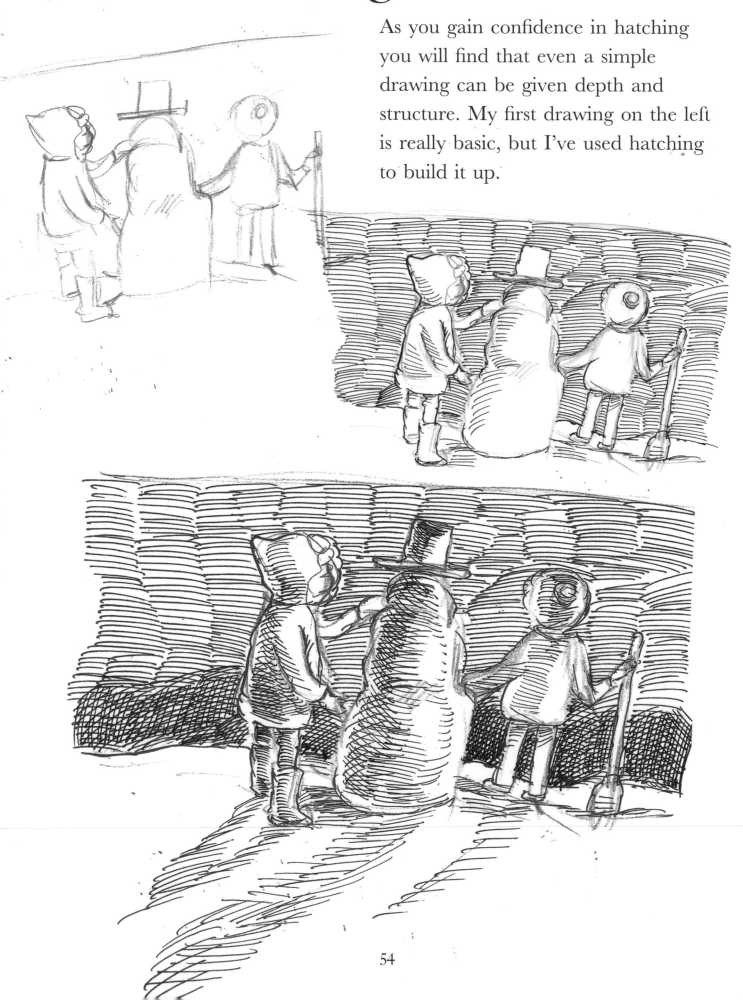

Now you try. Draw a simple picture, but then add as much hatching and shadow as you feel it needs.

Patterns

You can also use hatching to create dense patterns. Draw a light frame with a pencil, then add some lines across the space.

Then use different types of hatching in each part of the image.

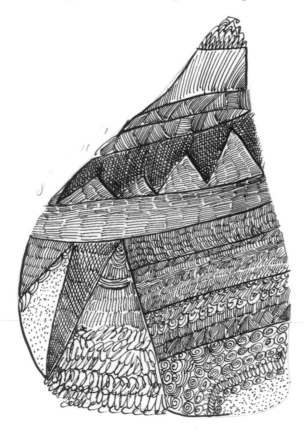

Use this page to try your own version.

57

Shadows

Here are some different ways of drawing shadows.

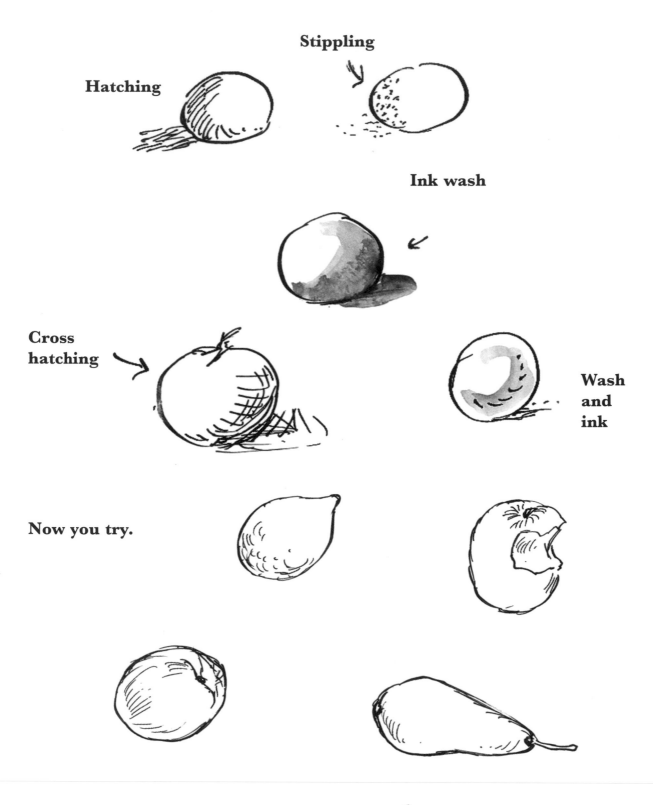

Stippling

Hatching

Ink wash

Cross hatching

Wash and ink

Now you try.

It's really obvious, but the first thing to think about when drawing shadows is where the light is coming from.

Complete this drawing by adding a friend and a sun, then draw the shadows.

This is one of those kids who loves sport.

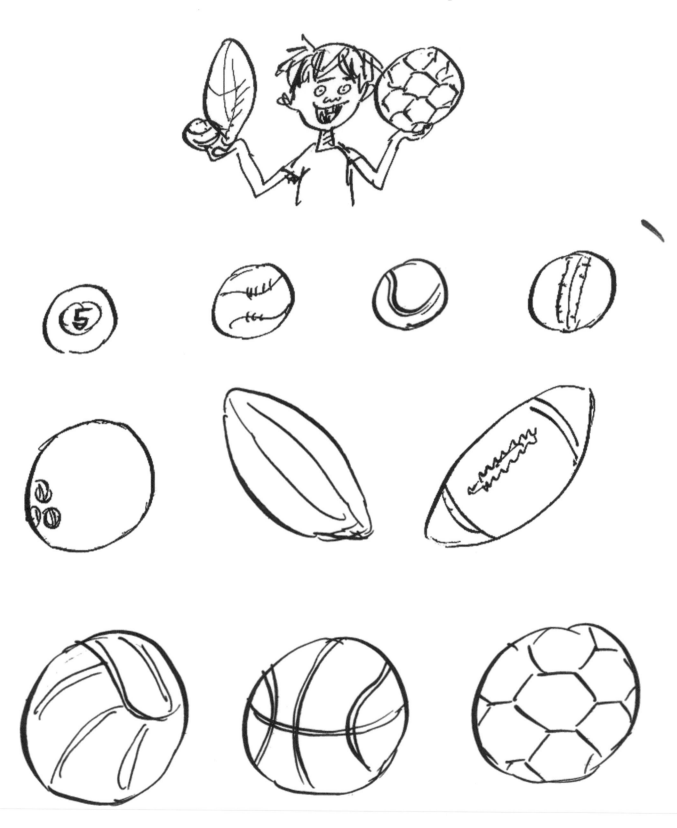

Add a mixture of hatching and shadows to his collection of balls.

Drawing People

Unless you are a hermit, there is usually a good supply of people who you can draw: spouses, children, friends, or yourself. When I need inspiration I walk around the town where I live and sketch the people I see there.

If you like people-watching, then you'll love drawing them.

The human body is hard to draw, no doubt about it: heads, necks, shoulders, torsos, legs, hands, feet, toes . . . How do they all fit together to make a man, woman, or child? Dressing them is a further minefield of folds, layers, lapels and shoelaces. Where do you start?

When you learned how to play tennis or how to skate, do you remember the moment when all the instructions piled up and your mind went blank? Somebody distracted you, perhaps with a joke, and you laughed and suddenly you were whacking the ball over the net, or gliding across the ice without your knees caving in. And once you had FELT the racket or skates doing their job, you could more easily replicate that feeling. On the following pages, there is a series of exercises designed to help you shift from that left brain stance, where you are worrying about the logical details, to your right brain, which is more intuitive, more visual, and helps you to see things holistically. This should help to ease you into the wonderful world of figure drawing.

Hands

Hands are often described as the toughest bit of anatomy to draw. You can get away with a bit of fudging on the body, but poorly drawn hands stick out like sore thumbs. Ever noticed how many artists and cartoonists depict their subjects with their hands in their pockets or behind their backs?

So much to think about!

The middle finger is the longest.

The nails are curved – like little roof tiles.

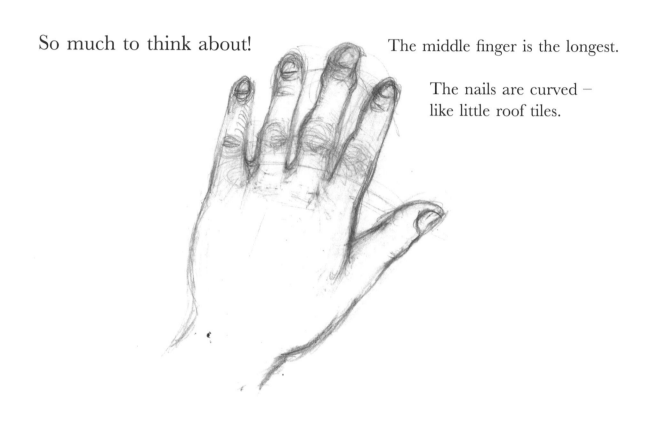

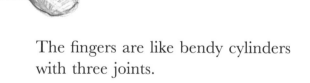

The fingers are like bendy cylinders with three joints.

The hand is bigger than it seems: in fact, a similar size to the face.

Blind Contour Drawing

This is a classic warm-up exercise. You are not going to look at your pencil or paper as you draw – so you are drawing "blind." Try to imagine that your pen is almost touching the edge as you outline the object ("contour" means "edge" in French). Avoid the temptation to peek. The result might be amusing – it may only faintly resemble the object – but the important thing is that you are easing yourself into drawing and setting up some hand-eye-brain connections.

Try a blind contour drawing of your hand below.

Cross Contour

For those people who love detailed and scientific drawing (and contour maps!) here is an exercise that makes you map out the surface of an object by drawing the lines that run across the surface or radiate from a central point. You are charting the shape to convey a 3D object. More or less space between the lines suggests expansion or contraction.

Draw your hand using cross contour.

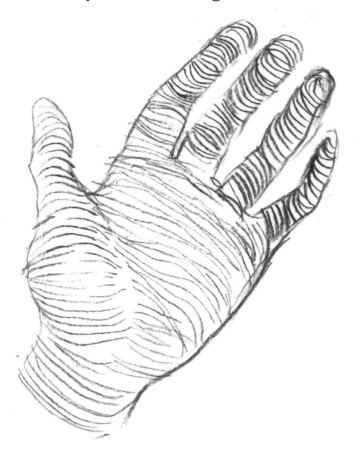

Find an everyday object and do a contour drawing below. Try to imagine the tip of the pencil is responding to the weight and volume of the object rather than to its edges.

In the two sketches on the right I was imagining I was drawing with wire and wrapping it around the object.

Coming back to hands, now try some time-limited sketches. Draw the shape as you actually see it.

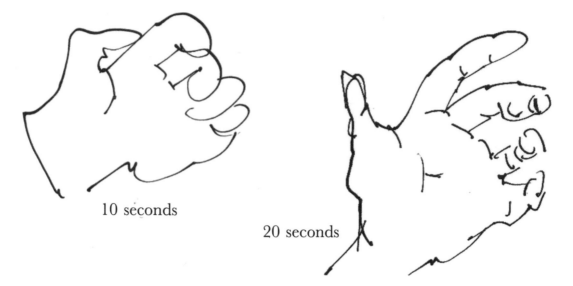

10 seconds

20 seconds

An Easy Way to Draw Hands

Draw a semi-circle.

Add a triangle.

Add a "knife-tip" to the top of the triangle.

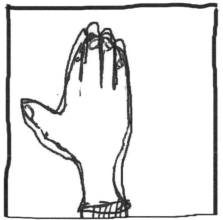

Add a flipped over semi-circle.

Smooth out the contours and add a wrist! And some fingernails for the final touch.

Now you try.

Flaunt Your Hands

Can you draw hands on these noisy boys?

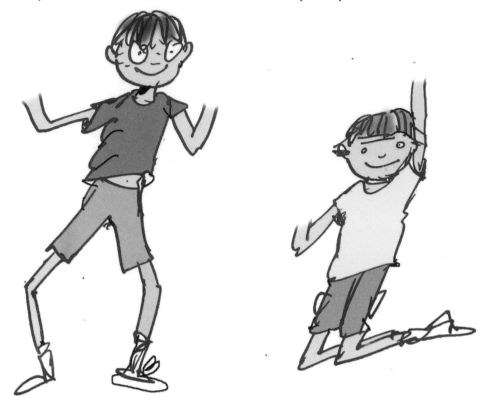

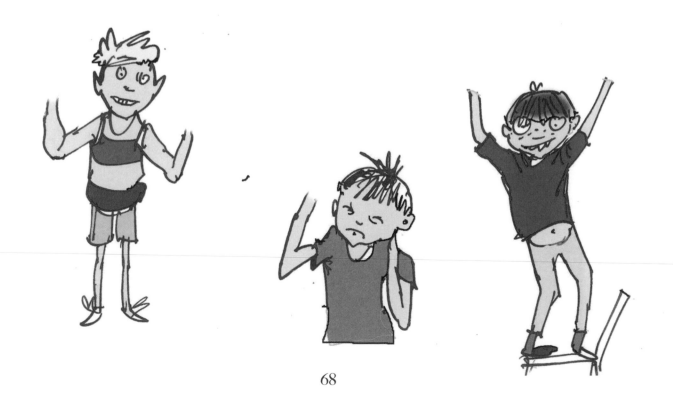

People

Now, how about some blind contour drawings of people. Find someone to pose for you, or use a photo. If you want to work larger, that's fine. Get another piece of paper. But start with a small drawing here.

And a bigger version here.

Contour Drawing

We have looked at blind contours. Now let's try some contour drawing (where you look at your drawing page!) Follow the edges without worrying about the detail, the textures or tone. We are after mass and volume here.

Take a little longer on your contour drawing. Choose a new person or photo to draw. Try to capture the stress points. Quentin Blake compares the challenge of capturing an essential emotion or gesture to "catching butterflies," saying "There is some flailing. You'll miss a lot, But your reward will be something startling and beautiful."

Go slowly. Concentrate on what is happening with the edge. Try to feel the line, as if you are transcribing it: every little bump, jagged bit or curve. Try not to think about what you are drawing (whether it is a tennis player, hand, elbow or foot). Just follow the line. The results are often erratic, but also usually interesting because of that.

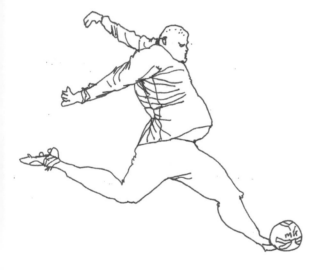

Gesture Drawing

Gesture drawings capture essential forms and proportions. They lack detail. The point is to record movement in the subject as well as speed up your own drawing. I've done a few below, in set times ranging from 30 seconds to two minutes.

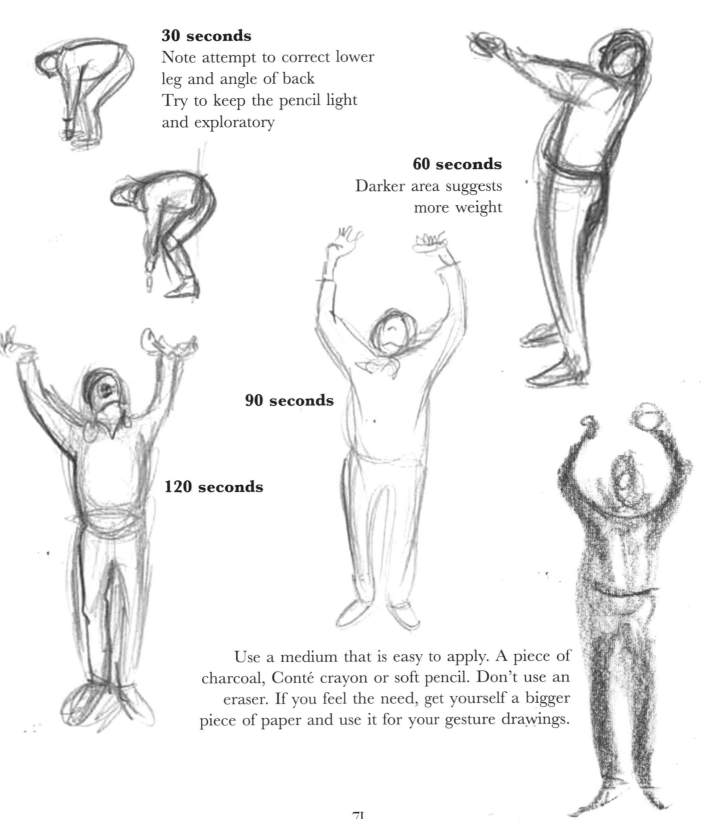

30 seconds
Note attempt to correct lower leg and angle of back
Try to keep the pencil light and exploratory

60 seconds
Darker area suggests more weight

90 seconds

120 seconds

Use a medium that is easy to apply. A piece of charcoal, Conté crayon or soft pencil. Don't use an eraser. If you feel the need, get yourself a bigger piece of paper and use it for your gesture drawings.

Find a new photo or person and give yourself 30 seconds to draw them.

You now have 60 seconds to try another pose or picture.

Now 90 seconds, with another new pose or picture. You will be feeling a bit more relaxed. Follow the lines that you see. Move your whole arm when you draw.

Finally try one in 120 seconds.

Moving on
Choose one of the poses you are happy with and spend 5-10 minutes working on a new drawing. Show movement and weight distribution. Use a darker line to suggest weight. Don't be afraid to correct as you go.

When drawing people, there are always new problems to solve, like drawing feet, or people running. Just remember not to be scared to have a go: find pictures or models to work from, and focus on the actual shapes and textures in front of you. And if at first you don't succeed, the only solution is to keep trying until you do.

Tips on Drawing People

I've been avoiding rules, but here are a few things to think about when drawing people.

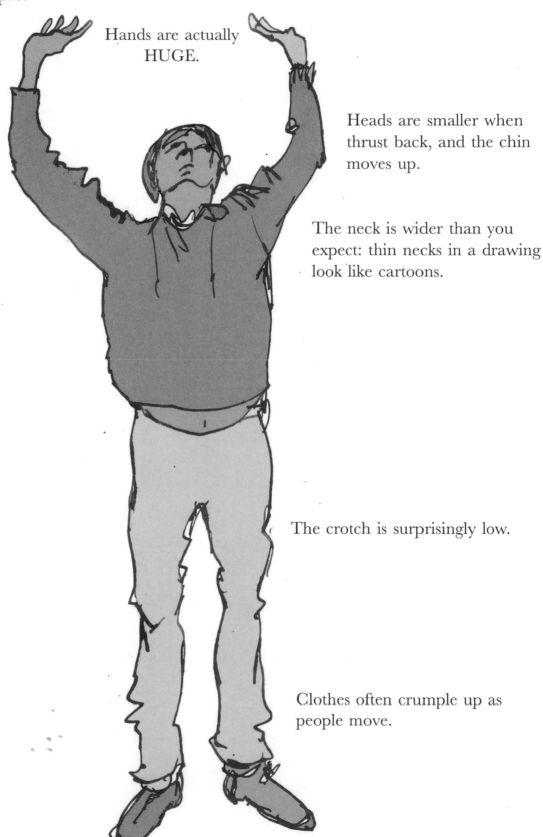

Hands are actually HUGE.

Heads are smaller when thrust back, and the chin moves up.

The neck is wider than you expect: thin necks in a drawing look like cartoons.

The crotch is surprisingly low.

Clothes often crumple up as people move.

The 8 Heads Rule

As soon as a rule is stated, the exceptions stampede in. Of course, there exists INFINITE variety in the human form. Bodies vary enormously in shape, size, and height across the continents, sexes and ages. Nevertheless, one method of measuring the human form is using the rule that men are roughly 8 heads tall, and women are 7½.

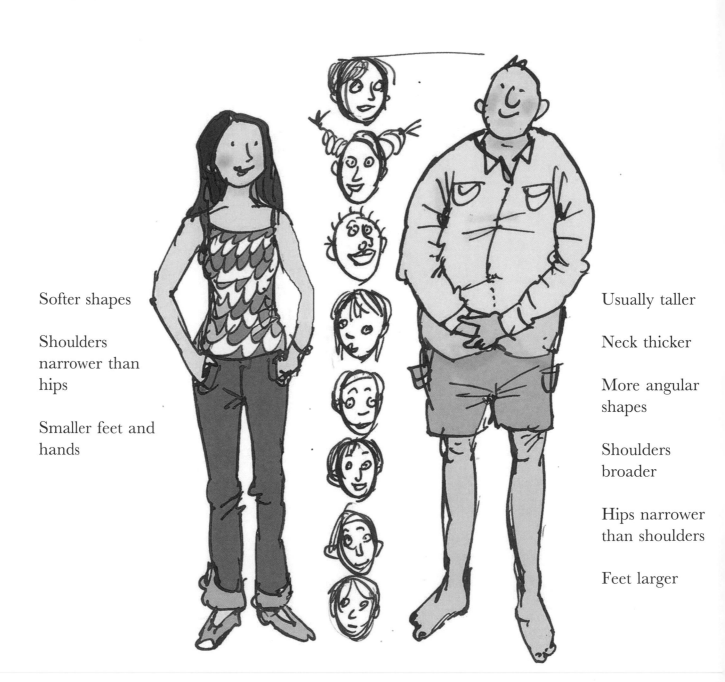

Softer shapes

Shoulders narrower than hips

Smaller feet and hands

Usually taller

Neck thicker

More angular shapes

Shoulders broader

Hips narrower than shoulders

Feet larger

Men and Women

Rules are best when they are broken: many women are taller than their partners.

Use this page to draw some funny couples. Complete the sketches or strike out on your own.

Hips

Most of our body actions start from the hips. People unfold when they move, one section at a time.

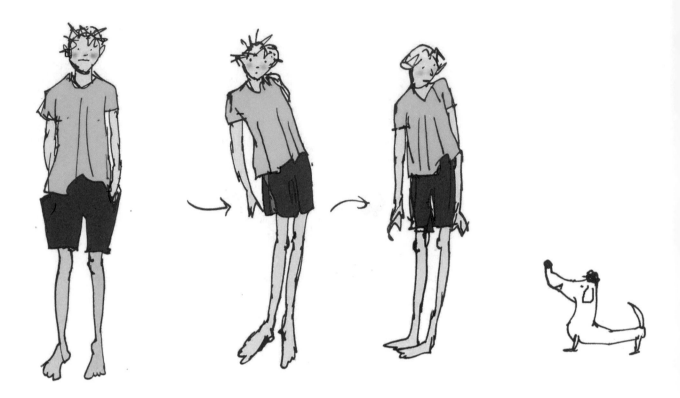

Draw someone dancing.

Walking

Every time you take a step, you use as many as 200 muscles. How does that translate into drawing, to create the illusion of motion? The first thing to notice is that we bob up and down as we walk.

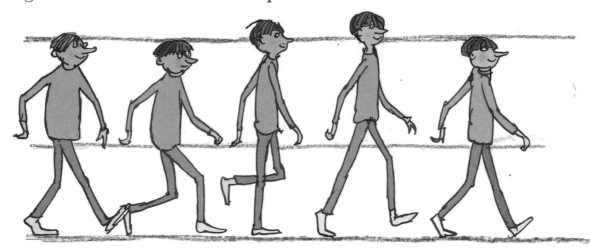

This is because walking is a process of falling over and catching yourself just in time. If we don't put our foot out, we'll land on our face. Normally, we only lift our feet very slightly off the ground. That's why a crack in the road can make us trip over so easily.

Draw someone walking.

Jumping

Make the bodies of your jumpers lean forward. Make sure to get the arms going or involve the feet. This helps to give the character direction and to avoid the "floating" effect.

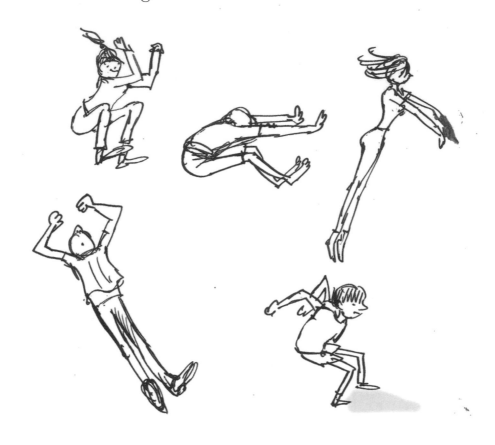

Draw your own jumpers.

Bodies in Motion

A great way to capture all kinds of movement is to draw people either playing sports or running.

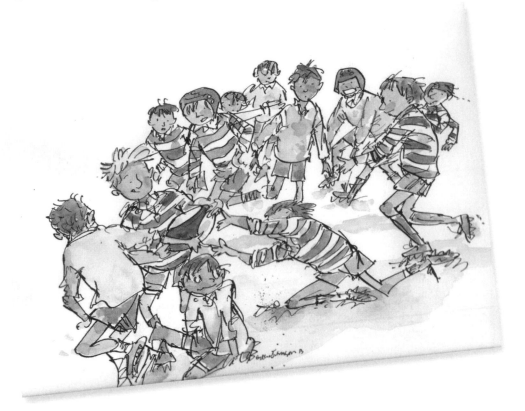

Use this space to draw some athletes or runners.

Drawing Faces

I remember drawing an eye in my science textbook in high school and studying it critically for a long time. My eye looked like no eye I had ever seen. Certainly no eye that existed in nature. I was aware of the impossible gulf between what I had imagined and what I had created. How could I ever be an artist?

Decades of practice have definitely improved my skill at depicting eyes. Why, then, is my level of dissatisfaction as high as ever? If anything, it has deepened and taken up permanent residence in my mind. I greet it like a slightly aggravating, compulsively honest relative. It's part of the furniture now.

Anyone who has tried to draw or paint (or dance, sing, or write a poem or novel) has come up against that naysaying, finger-wagging voice.

But dissatisfaction is the driving force behind so much art. That moment of despair turns into renewal and pushes us forward. It drives us to start over again.

My next eye will be better.

Martha Graham writes that "No artist is pleased. There is only a queer divine dissatisfaction, a blessed unrest, that keeps us marching and makes us more alive…"

The human face demands this kind of stubborn commitment from the artist. Draw, redraw and redraw again. But if you haven't drawn many faces, here are a few tips that might be useful. First, the eyes are usually halfway on the head – between the top of the head and the bottom of the chin. We call this the Halfway Rule.

82

The Halfway Rule

Most heads are roughly oval in shape, like an upside-down egg. The halfway rule is a rough guide to where the eyes, nose and mouth should go. It works like this:

Eyes halfway between the top of the head and the chin.

Nose halfway between the eyes and the chin.

Mouth halfway between the nose and the chin.

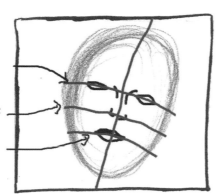

This head is slightly tilted so the lines across will be slightly curved.

When you draw heads, use a light, searching line that you can modify or erase if you need to. The line down the middle helps to track the bridge of the nose.

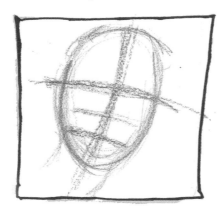

Lightly sketch in the eyes, nose and mouth. The space between the eyes can alter appearance dramatically. Mouths are also revealing of character.

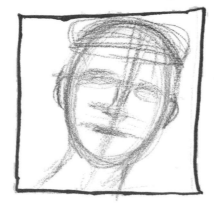

Necks are unexpectedly thick. The bottom of the ears line up roughly with the bottom of the nose, though it can depend on the angle of the head.

Here, I am starting to commit to the position of the eyes, nose and mouth, and to build up the darker tones and shadows.

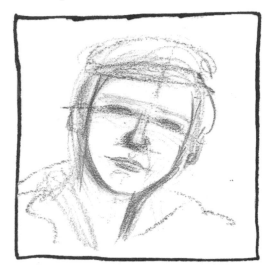

Copy the head on the left or try your own in the boxes below.

I have removed the halfway rule lines with an eraser . . .

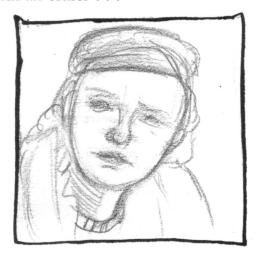

. . . and worked up the shadow cast by the hat and the chin.

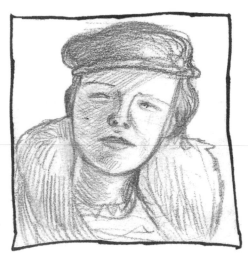

Eyes

"Almost nothing need be said when you have eyes," wrote the poet Tarjei Vesaas. Eyes can be drawn in many ways, but if you are after realistic eyes you need to remember that eyes are made up of curves and circles. The pupil is the black dot, the iris is the larger circle, and the surface of the eye curves because the eyeball is in fact a slightly asymmetrical sphere.

Have a go. Draw your own eye or eyes below.

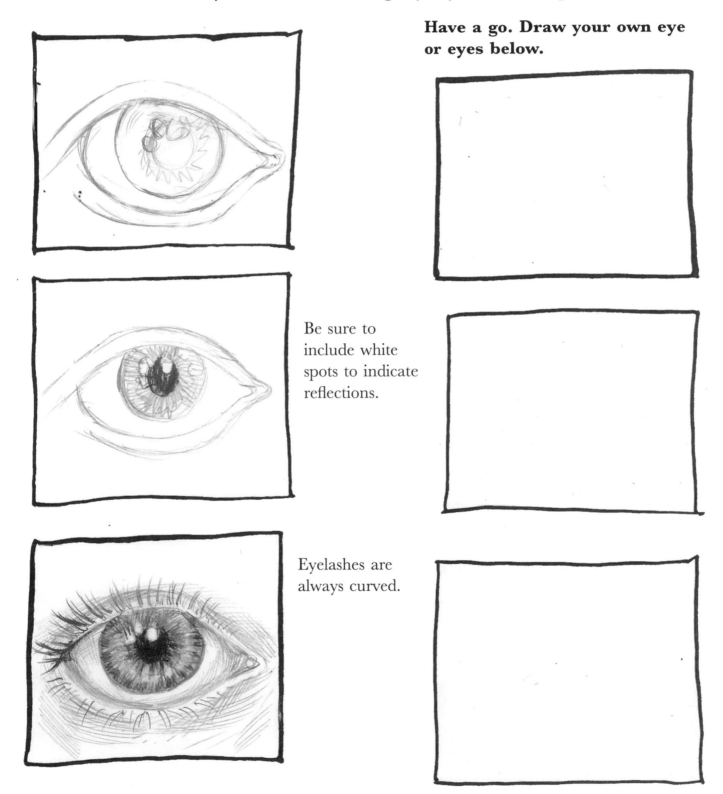

Be sure to include white spots to indicate reflections.

Eyelashes are always curved.

Noses

The nose is made up of a series of angles and planes, some more subtle than others. There are three wedges: the first is between the eyes, the second is the diamond-like plane in the middle, and the third is the bulb at the end of the nose. The strongest shadows are in the nostrils. The nose tends to cast a shadow above the lip. Shadows also appear in the slight fold between the edge of the nostril and the cheek. The tip of the nose is sometimes segmented but, in any case, it reflects small bits of light.

Start by drawing the outline very lightly.

Copy the nose on the left or try your own.

Keep the bridge of the nose free of shadow.

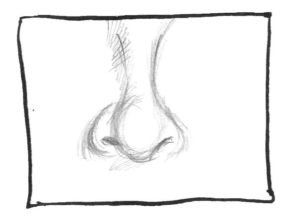

As you build up the shadows, the nose will emerge.

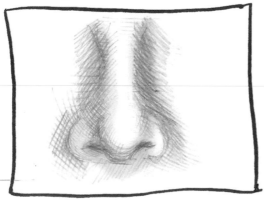

Lips

Lips are hugely variable, person to person, but there are some basic principles that apply to all types, sizes and shapes. Try to avoid a dark outline or the lips will look fake, as if they have been pasted onto the face. Softening the edges will connect the mouth to the face.

Start by finding landmarks (corners, the bottom of the lower lip, and the central division).

Copy the mouth on the left or try your own.

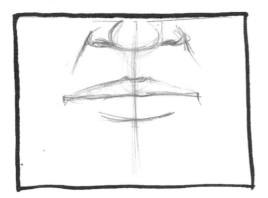

Lay out the shapes and shadows.

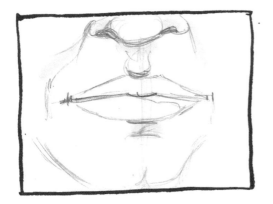

Darken the top and blur the line on the bottom of the lower lip.

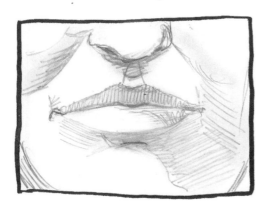

Caricatures and Expressions

A single face is capable of around 5,000 expressions. But it is still possible to capture the essence of a person in a caricature. On every face, the features relate to each other in a special way. The caricaturist or cartoonist has to figure out something true in these relationships. In other words, it is not just a matter of making the nose bigger or the chin longer, but in capturing something about how all the features work together, and giving the face an expression. Bear in mind that we needn't follow the halfway rule for a caricature.

The core expressions are happy and sad. In happiness, the mouth curves upwards and the eyes may become smaller as the cheeks lift up. Surprise is often a variation on happiness: here everything lifts, the eyes widen, the nose lifts up and the mouth turns into a tall O. In sadness, we get a reverse of the happy face. The mouth curves down and the eyebrows lift quizzically. Worry causes the lips to thin a little and the brow to gather some extra lines. You can experiment by altering the angles of the eyebrows, the curve of the mouth, the width of the eyes. Smiling with the mouth closed as opposed to mouth open can alter the face dramatically.

Shorthand caricatures in three steps:

1. What is the essential head shape? Square? Heart-shaped? Rectangular with a chin?

2. Place eyes, nose, mouth, and basic hairline.

3. Add distinguishing details such as hair, glasses, earrings . . .

Draw a Caricature

In the space below, try drawing a caricature of a famous person or friend. Emphasize the features that are unusually large. Scale down the features that are unusually small. You are trying to boil your subject down to an essence. In the end, your image either looks like your subject, or it doesn't. If it doesn't, don't despair. It may just need a subtle rearrangement in the eyes, or maybe the chin is not quite right. Accept that you'll need to practice a few times before you can capture your subject.

Fill in the Faces

Emotions are conveyed through a variety of facial expressions. The tiniest detail can have a dramatic effect. A crease between the eyes, a dimple in the chin, shadows indicating deep-set eyes or fatigue . . .

Can you convey some of the following emotions?

Scared Pompous Disgusted Mischievous Sad
Flirtatious Triumphant Shy Happy

If your faces didn't come out the way you intended, write under each box what you think their expression DOES look like. Then you can pretend you meant it that way all along.

Drawing Hair

There are more than 100,000 strands of hair on the average head.
I have always found hair difficult to draw: too often my characters
look like they are wearing wigs . . .

Drawing hair is not about drawing individual strands, though: it's about drawing
dark, halftones and highlights, and getting the shapes right. In the drawing below, I
think the shapes are working well, but the halftones could be more pronounced.

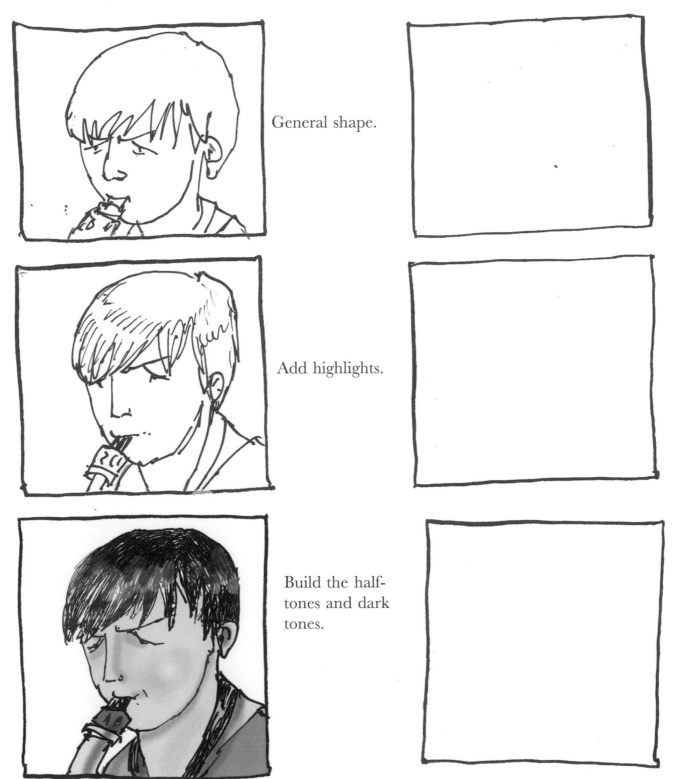

General shape.

Add highlights.

Build the half-
tones and dark
tones.

Hairstyles

Hairstyles come in so many different varieties. Here are a few ideas
(you can fill in the faces if you want).

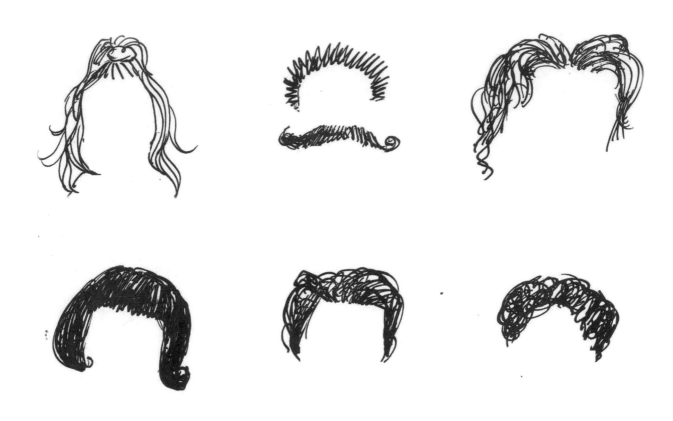

Or you can play around with other art materials . . .

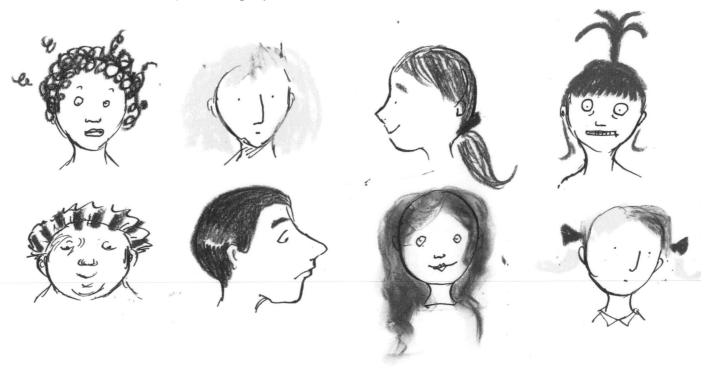

These folks need hair. Invent your own hairstyles or borrow from the hair on the opposite page.

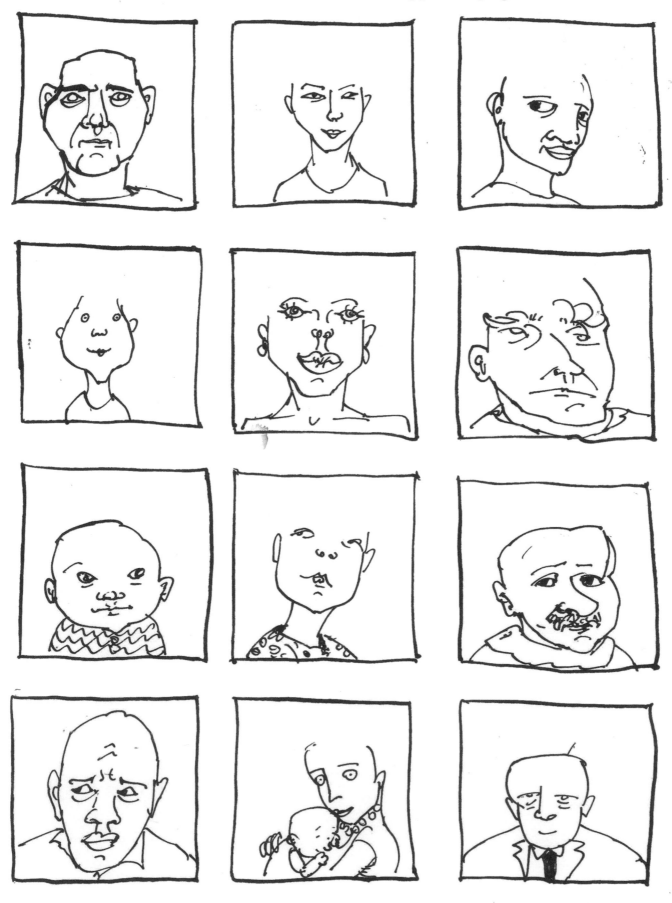

Animal Crackers

The animal-shaped cookies you might have eaten when you were a child were not anatomically accurate, but you always knew what they were meant to be.

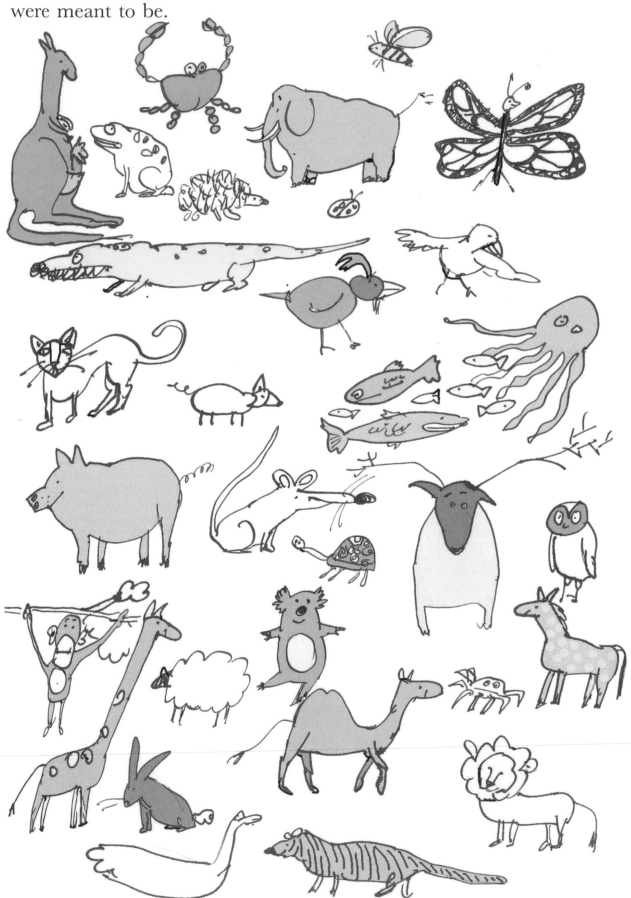

Draw a dozen animal crackers. Don't spend more than a minute on each (or however long you might take to eat one).

95

Pen and Ink Birds

When you draw with ink, you need to go with the flow, because ink really does have a life of its own.

Using a clean paintbrush, wet the area inside the box with water.

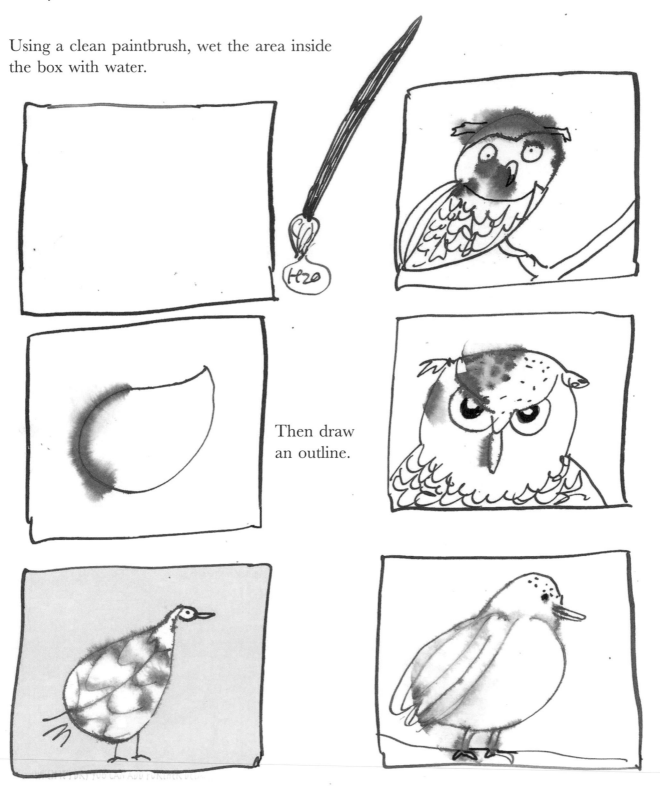

Then draw an outline.

Add birdy details: head, feet, feathers, beak. When it's dry you can add further detail in ink if you like.

The wetter the box, the more blur you will create. It's hard to control, but that's why it creates interesting effects.

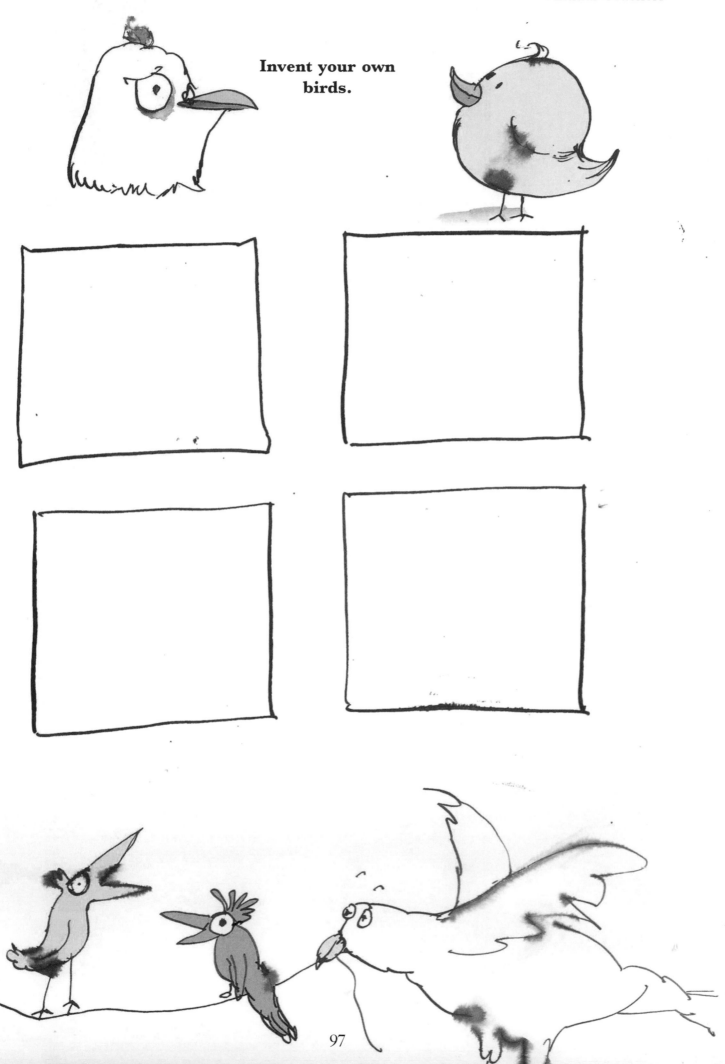

Invent your own birds.

97

Smudge Drawings are Good for Animals Too!

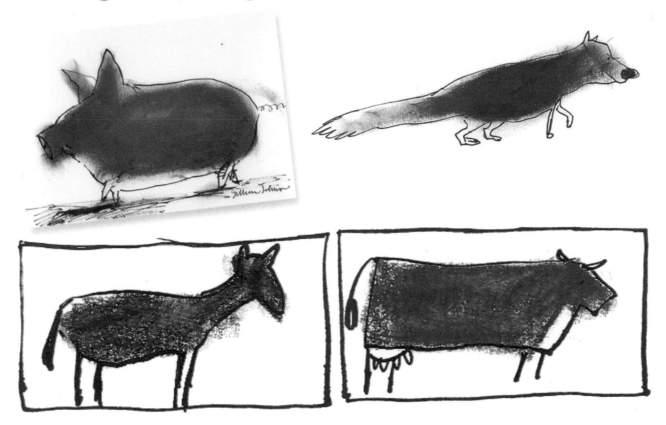

You try some.

Imaginary Animals

Why not make up some of your own animals?
How many legs do they have? Furry, feathered, scaly?
Antennae, horns, antlers? Spots, stripes or zig-zags?

Draw A Special Animal Here

Cats and Dogs

It's fun to draw your pets – think about the little details that give a cat or dog their particular character.

Cats

Dogs

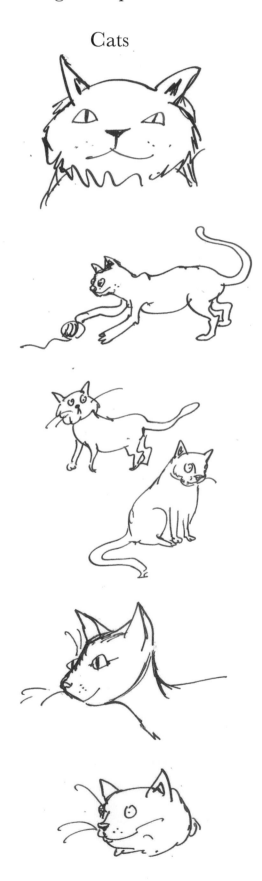

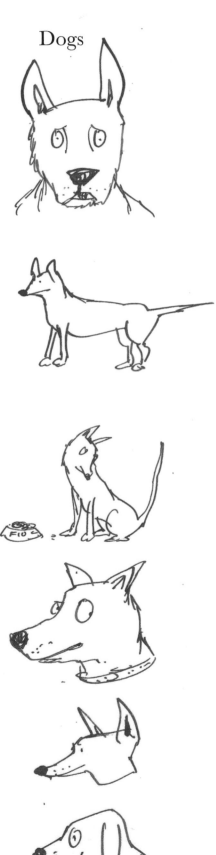

It's Raining Cats and Dogs!

You fill in the page . . .

Big Cats

When drawing a type of animal, observe the particular characteristics of the species, especially the shape of the head.

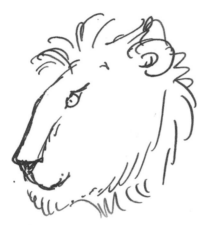

The lion has a long face and a fluffy chin.

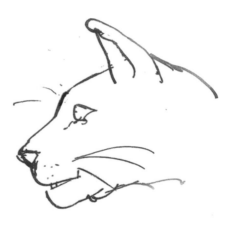

Mountain lions have large fluffy ears, skinny necks and round chins.

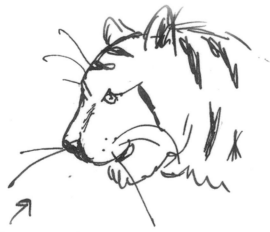

Tigers have round faces and lots of whiskers.

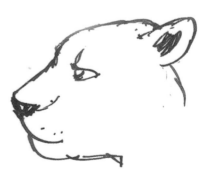

Cheetahs have a protruding brow and a doglike nose.

Flying Creatures

Draw a sky full of bats, birds, butterflies, or even pterodactyls above the church.

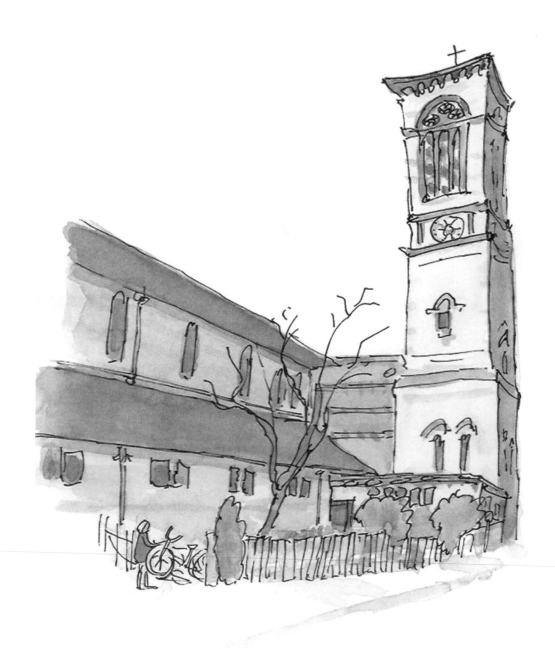

How to Draw the Things You Can't Draw

We all have the experience of trying to create a likeness that falls short of the real thing. It can be discouraging. But if it's any consolation, this is normal. In fact, it's a sign of artistic health. (There is a baring of the bones in drawing. It is hard to hide from the truths it reveals. Gauguin called his drawings his "secrets.") Drawing can be an unexpected looking glass. It might, in fact, be one of the most honest things you can do.

Don't worry about how your work is seen or received in the world. Draw for the sake of it. Draw because it feels good. Draw because you need to. It's free. It's organic. It returns you to yourself.

When it comes to drawing, we all have our Achilles heel. For instance, I simply cannot draw landscapes. Lucky you if you can. I grew up in a lonely bit of the prairies where the big skies and flat wheat fields filled me with an appetite for people and action. Our subjects as artists reflect our backgrounds, our interests and our character. That said, there are ways around most weaknesses, so let's look at some of the tricks that can be used when you have to draw something that doesn't come naturally to you.

Fudging It

A little non-specific foliage will suggest the outdoors – but there is no need to get caught up in all the specific plants and trees.

The drawing below is meant to be tropical, perhaps Polynesian – thus the big coconut palms and lily pads. But I am not trying to win a botanical art award. I just want to suggest fecundity by crowding the girl with a range of leaves, trees and flowers – all drawn quickly with what I hope are tropical shapes.

Extend the jungle in the background in as few lines as possible.

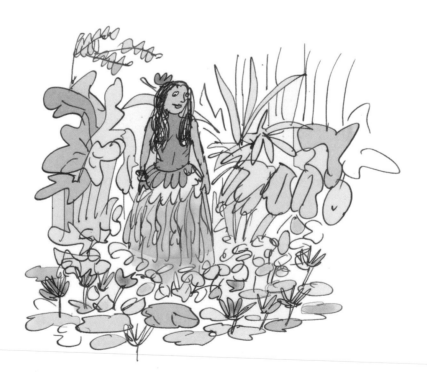

The trees are hinted at, but I hope it is clear what they are supposed to be.

Draw a frame of foliage around the girl along the right and left edges of the page, as well as along the top. This will suggest trees in the foreground.

Framing It

How you frame a picture can make a huge difference. These houses are too large for the page, and so appear crowded. Nobody, I hope, can see the many architectural weaknesses.

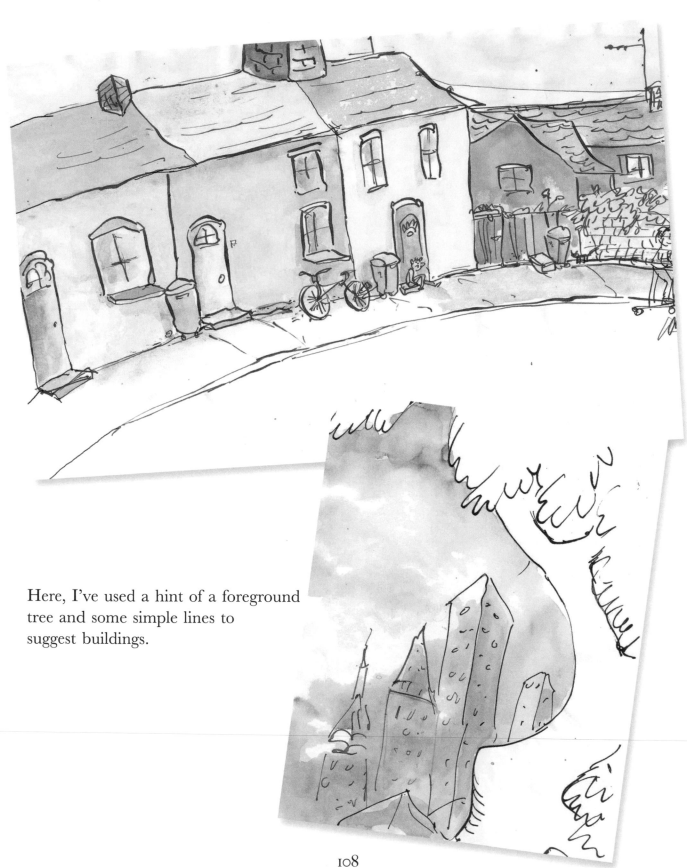

Here, I've used a hint of a foreground tree and some simple lines to suggest buildings.

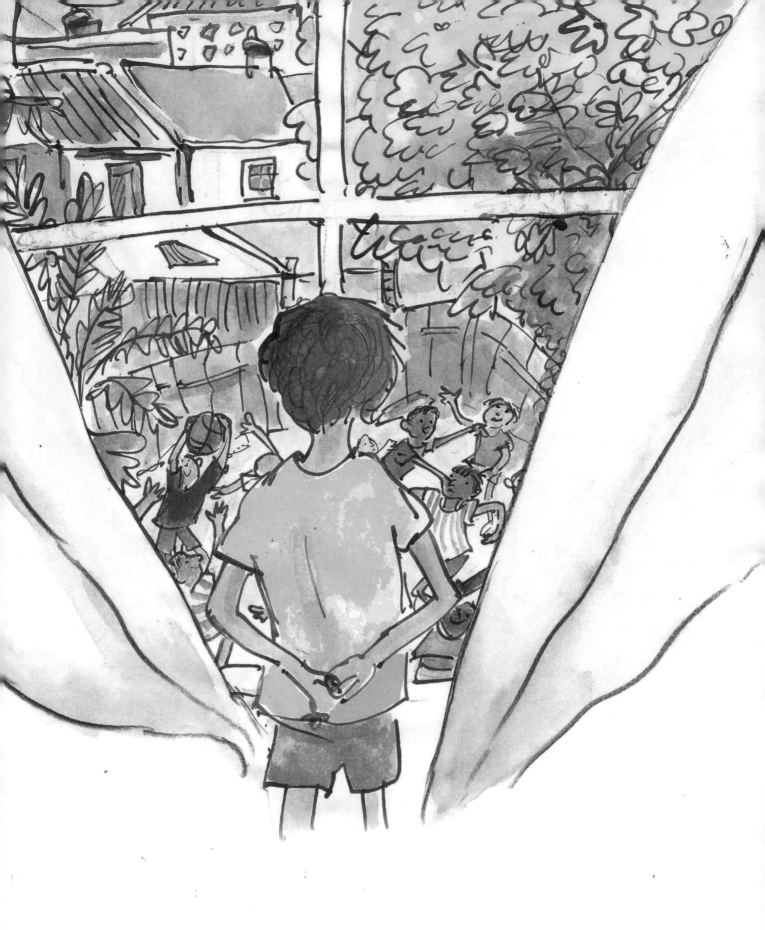

This is ink and watercolor: I've fudged the buildings and trees with
some curtains and a boy. When a scene is this crowded, mistakes are
sometimes overlooked!

Selective Detail

The fence, trees and part of the building have been drawn with a pencil and charcoal – the doorway has been rendered with a bit more care in ink, and helps to give the building character.

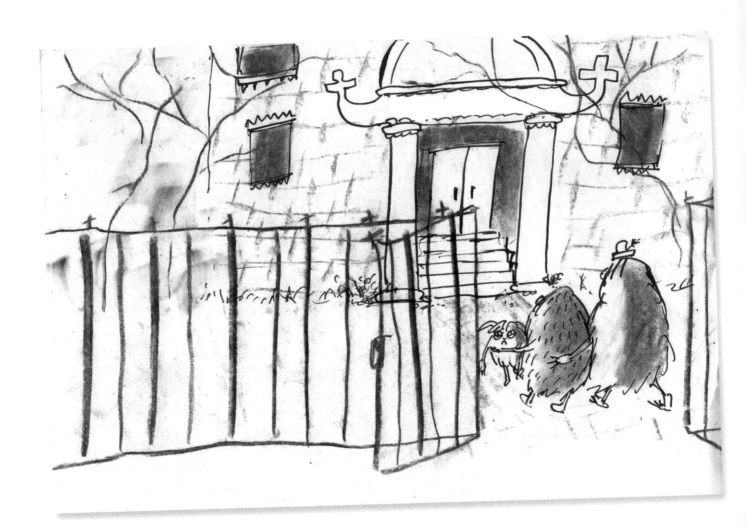

Draw a building and pay special attention to one particular window or door.

I always dreaded it when my boys asked me this. BUT ASK THEY DID . . . As a result I had to practice cars, trucks and vans over and over again. Eventually, I learned how to fudge it with the help of some wax crayons.

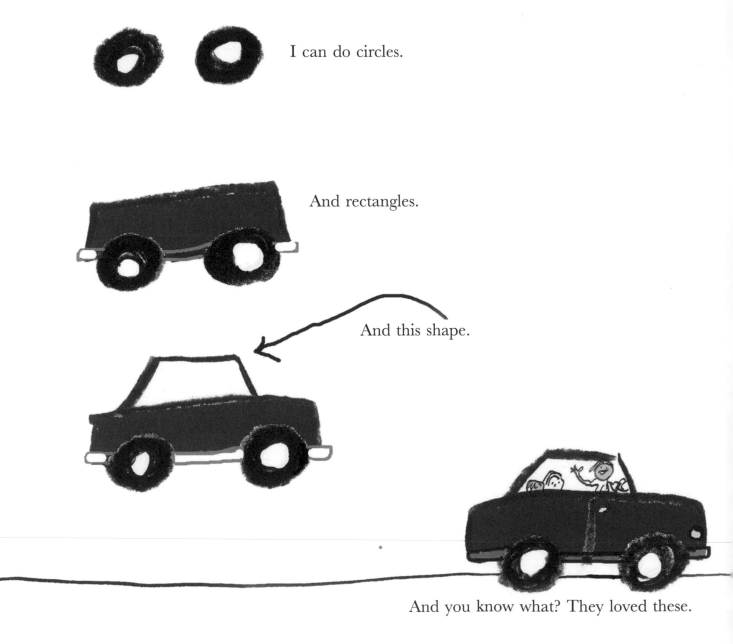

I can do circles.

And rectangles.

And this shape.

And you know what? They loved these.

Create some cars like this in the boxes on the right.
Remember, it's just circles and squares, with a few extra details.

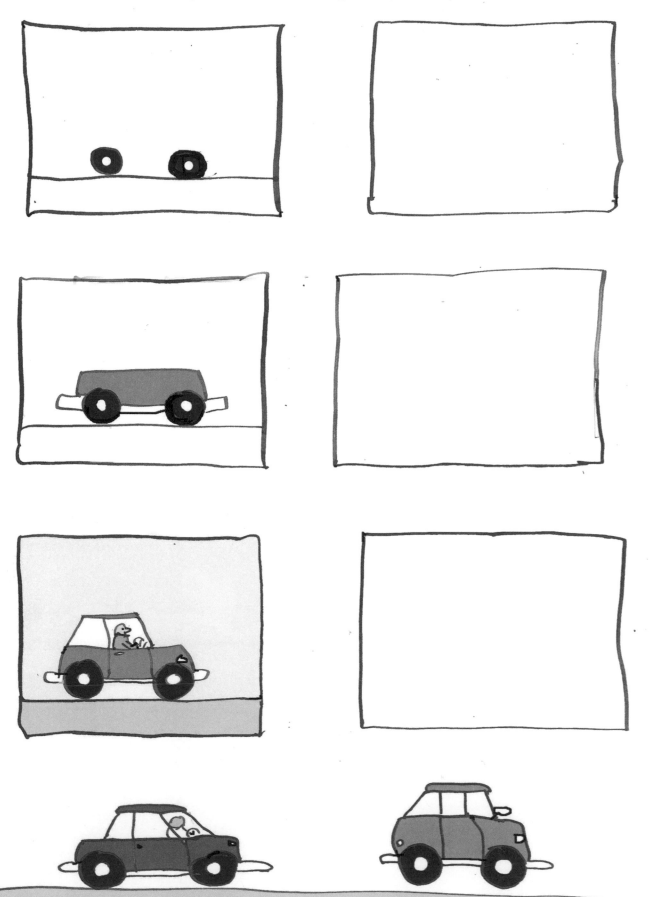

And you can build up a collection of these crayon vehicles using different shapes and details.

My boys always made sure we included the lights, door handles, and the fenders! And bumpers!

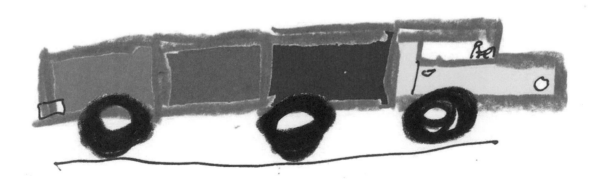

I always made sure to include
a driver.

Draw different kinds of cars, trucks and buses on this page.

115

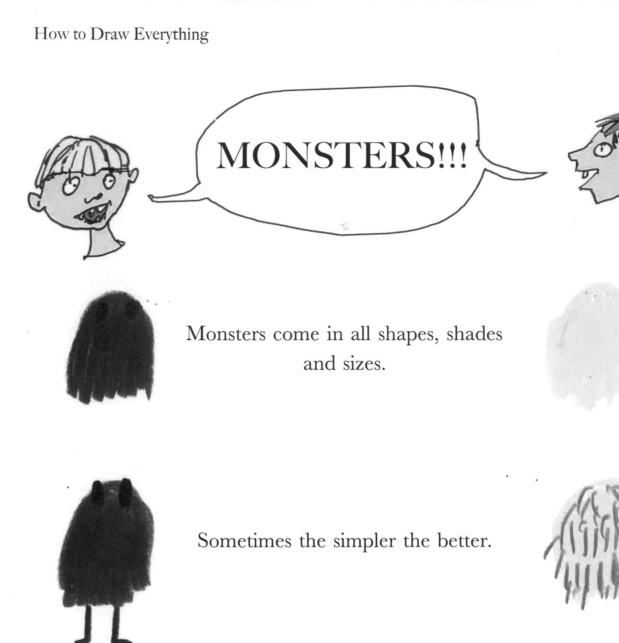

MONSTERS!!!

Monsters come in all shapes, shades and sizes.

Sometimes the simpler the better.

Generally they need eyes and teeth though how many is up to you.

Try different poses . . . bend their legs or stretch out their arms.

Children have a particular genius for drawing monsters. Find a young person to give you some pointers, or imagine your eight-year-old self drawing the monster that lived under your bed.

The Cave

The bumpy surface is a rubbing
achieved by placing the paper on a textured
surface and rubbing the flat end of a
Conté crayon over it.

Draw the outlines of a family of monsters, aliens or trolls in the cave.

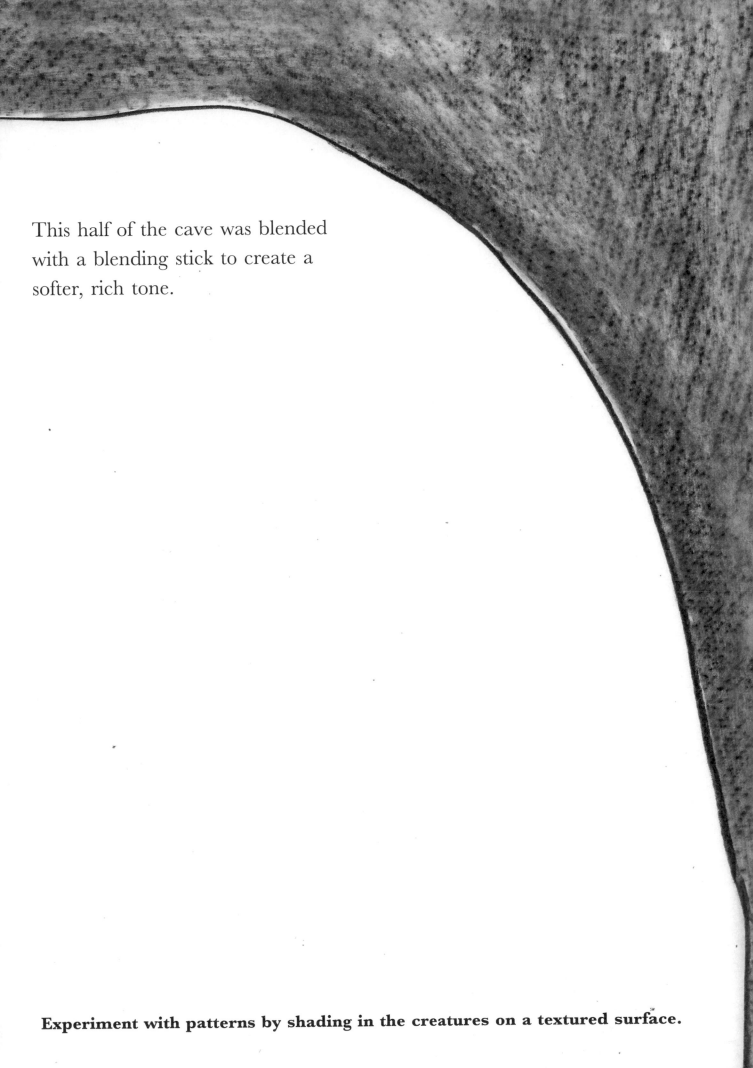

This half of the cave was blended with a blending stick to create a softer, rich tone.

Experiment with patterns by shading in the creatures on a textured surface.

Dress These Folks

The Hottest Day of the Year.
Make their outfits more interesting.

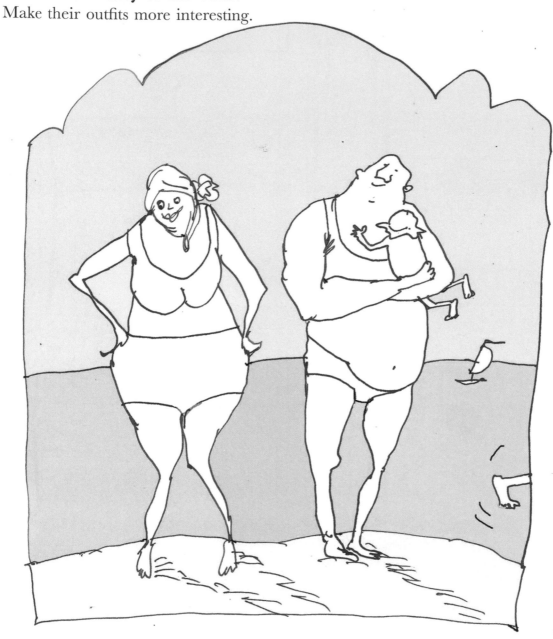

The Arctic Expedition.
Make their outfits more appropriate!

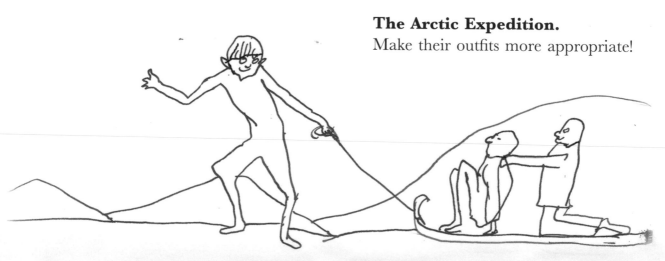

A Project

We've used a lot of different techniques through the book. Here's an example of how you can bring these together while working on a single project.

I wanted to draw my friend's dog, Laddie. First, I took a series of photographs as source material. (Dogs are not the most patient models and so photographs are a valuable source of information!)

Here, I have done a quick tracing of one of the photos, in order to start understanding the dog's shape. (This is similar to doing a blind contour drawing, which would also be a useful first stage.) Tracing photographs is never going to produce an interesting drawing per se, but it helps acquaint you with basic shapes and positions. See it as information gathering.

Then I drew over the original tracing using a Conté crayon. (Many professional artists use light boxes to trace their own work.) I place a piece of good quality paper over the drawing, switch on the light box and do a sort of draw/trace of the image below. I don't want to draw every line and hair the same, just to use the first image as a rough positioning guide. Having the image under the good paper gives me the freedom to draw without worrying too much about proportions and the result is often more interesting and certainly freer. Of course, the drawing can go wrong. But every failure is, as they say, success postponed.

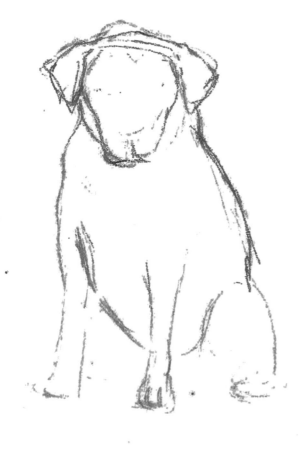

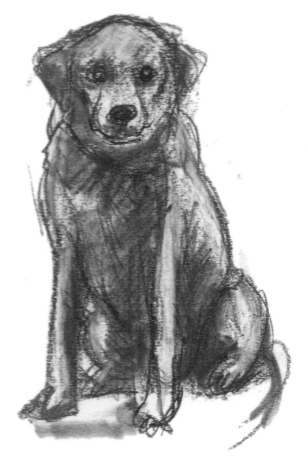

Using a Light Box

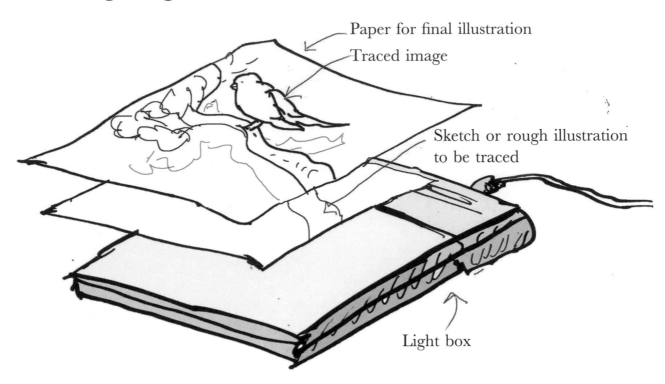

Paper for final illustration

Traced image

Sketch or rough illustration to be traced

Light box

Here, I took the drawing on one step closer to realism.

However, I decided this pose was lacking a bit of life, so I tried a few other approaches to loosen things up again. First, I tried a contour drawing using a different photo.

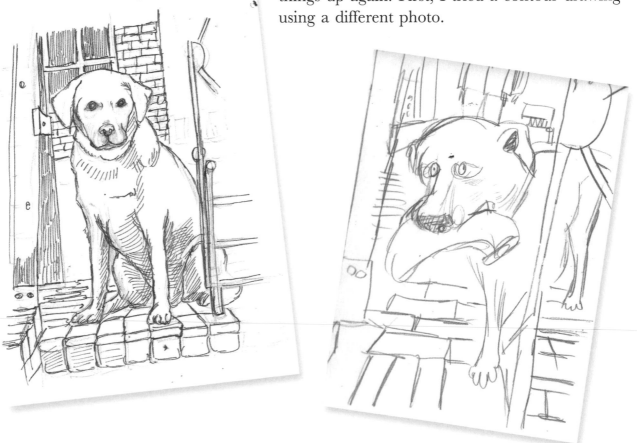

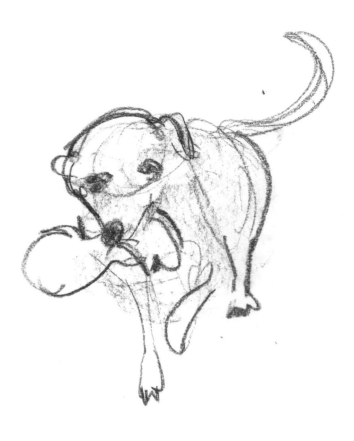

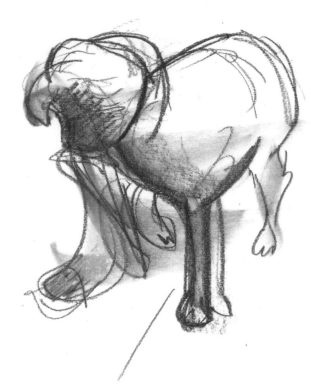

Then I did a one-minute sketch of the same pose . . .

. . . then a two-minute version, adding a few minor variations.

Next, I tried a different pose. This is a five-minute drawing, then I took another five minutes to work on the face in a bit more detail.

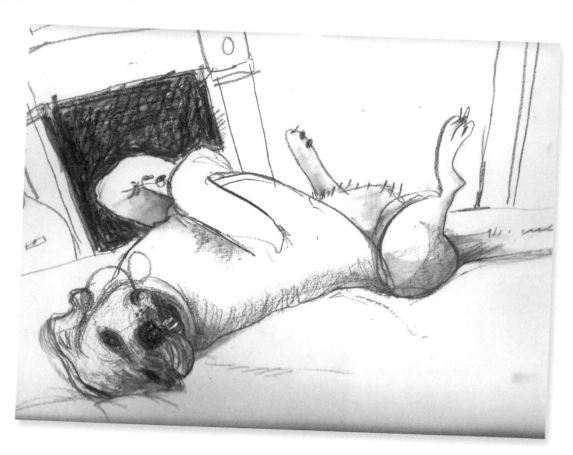

At this point, I was getting a better feel for what I wanted to do, so I tried a couple of extended sketches.

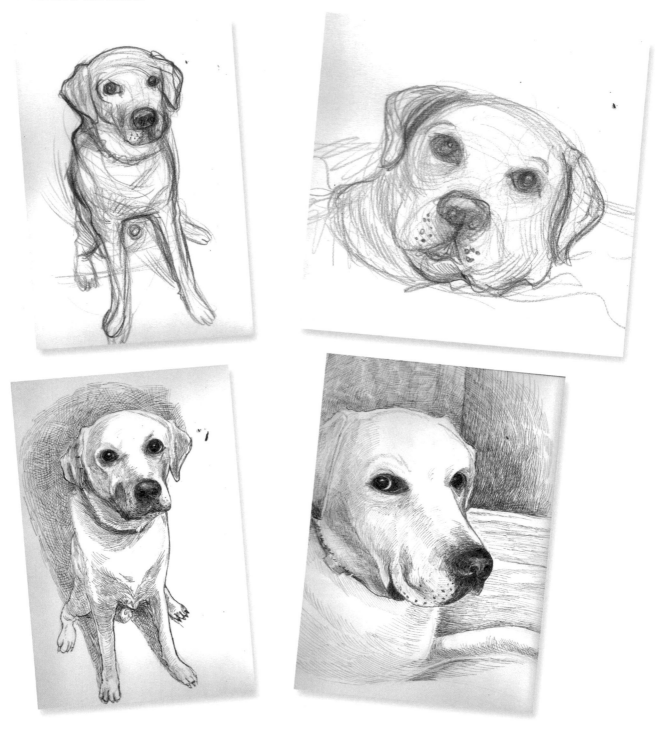

And finally, I moved on to more careful studies of Laddie, adding detail and hatching to create greater depth and structure. The result is OK. And now I might begin all over again with a visit to Laddie's home and some live-action drawings – which I can do with a lot more confidence because I have really studied Laddie's physiognomy and come to know his defining characteristics.

Now it's your turn – think of a subject you want to draw, and do a series of sketches before producing a finished drawing that is based on them.

Flowers and Friends

The poet and writer, Emerson, said that the earth laughs in flowers. Flowers are happy things to draw. Like dogs, they give off positive ions — but they smell much better.

The beauty of drawing flowers is that your studio can be outside in nature, in a vase in your house or you can use photographs and images off the internet.

Don't get me wrong. Flowers are not always easy to draw. Sometimes the composition can throw you off. Or the edges can appear as lines and make your flower look rather like a cartoon. Flowers demand close attention to tones: dark, medium and light. They contain a world in a small orbit.

There are different ways to approach the problem of drawing a flower. You can aim for realism or a more cartoonish look . . .

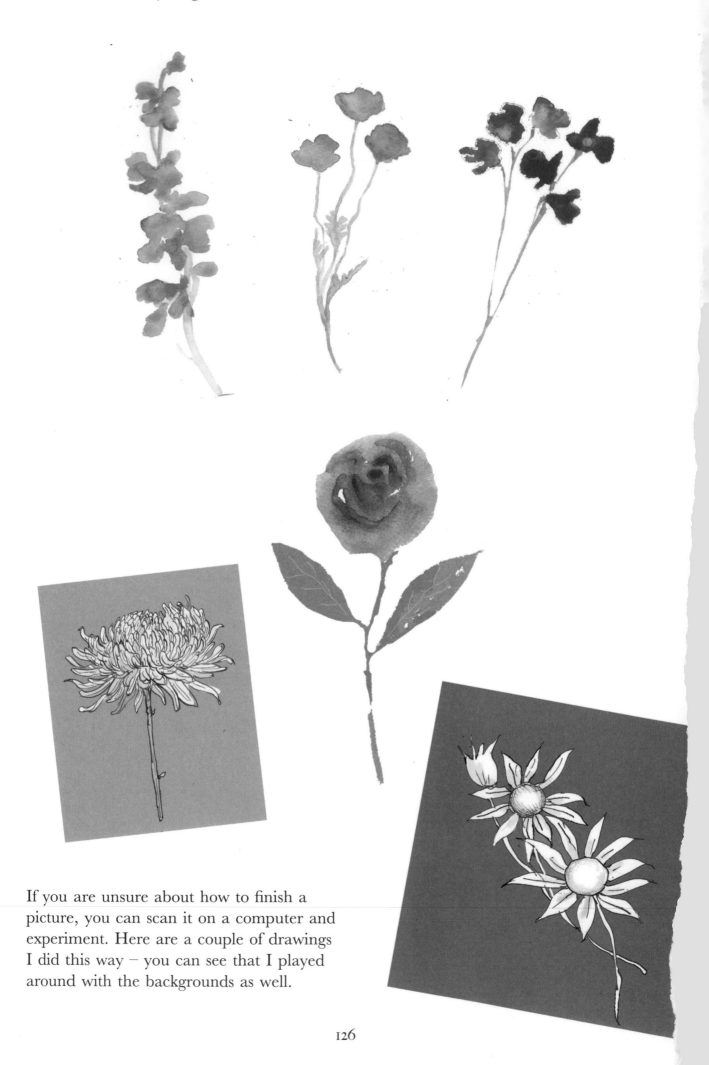

If you are unsure about how to finish a picture, you can scan it on a computer and experiment. Here are a couple of drawings I did this way – you can see that I played around with the backgrounds as well.

Here's a page to try a few flowers of your own.

Remember, if you have got this far and you still don't feel like a proper artist, then you're in good company. Degas, da Vinci, Michelangelo and Van Gogh all had their panic attacks when confronted with the blank canvas, wall or even sunflower. You can be sure that they made their fair share of mistakes too. There are very few artists who have not worried that their work is not good enough. The art critic, Robert Hughes, wrote that "the greater the artist, the greater the doubt."

Getting Your Friends Involved

Sometimes we forget that drawing does not have to be a solitary activity. Of course, there are classes and group activities. There are exhibitions and contests. And now we also have social media, a potentially vast network of fellow artists and art lovers with whom we can share and discuss our work.

There are dozens of online art groups you can join. You simply need to have a mechanism for scanning your artwork and posting it. These groups are populated by people like me and you, who want to see their work out in the world. It's rather wonderful to "publish" a drawing online. You immediately look at it differently. It assumes an autonomy and completion that it might not have sitting alone, unobserved, in your studio.

As I was working on this book, I tried an experiment. I asked my online friends to tell me which flowers they would like me to draw for them as a gift. I was surprised (and pleased) by the number of requests I received. My brother, Dan, requested a Dandelion . . .

Here are a few more flower drawings I gave to people.

For your final project, why not ask your friends what you can draw for them and post the results online?

While working on these flowers, I was happy to realize that I have now overcome my drawer's block. Do I now know exactly what I am doing? Absolutely not. All I can say with certainty is that working through my block has taught me what Salvador Dali already knew. "Have no fear of perfection," he advised. "You'll never reach it."

The important lesson here is to accept that you might not always get it right, and to keep going, without letting the fear of failure hold you back. What you will then, I hope, succeed in doing is to draw out and celebrate the artist within. As Samuel Beckett said: "Try again. Fail again. Fail better!"